An OZARK Culinary History

Northwest Arkansas Traditions from Corn Dodgers to Squirrel Meatloaf

Un God bless you full!

ERIN ROWE

EDITED BY ALEX MARTENS

AMERICAN PALATE

Published by American Palate
A Division of The History Press
Charleston, SC
www.historypress.net

Front cover, top right: River fishing in waders is the best way to catch Ozark trout. *Rogers Historical Museum*; *back cover, top*: Two young hunters proud of their rabbit kill. *Rogers Historical Museum*; *back cover, bottom*: Two Siloam Springs sportsmen, T.A. Trowbridge and O.P. Maxwell, display a flock of fresh-killed ducks. *Siloam Springs Museum.*

First published 2017

Manufactured in the United States

ISBN 9781467136082

Library of Congress Control Number: 2017940941

Lord, you establish peace for us;
all that we have accomplished you have done for us.
—Isaiah 26:12

This book is dedicated to the Lord who blessed me with a loving husband, Alex,
to champion my dreams; friends and family to support and help me;
and this whole opportunity to write in the first place.

CONTENTS

FOREWORD

It is so exciting to be here—celebrating our farmers and delicious, locally grown food.

I think there's a temptation to view gathering out here on this beautiful farm with a sense of nostalgia. But I would like to argue that what we are doing is actually something very new.

We're all here as the restless descendants of immigrants. We are the people who have been defined by leaving, people who believed in new opportunity someplace else and moved on. You might say this has become an American tradition: stay until the land is exploited, then move on.

So what we're doing is new. We are choosing to stay and figure out what staying will look like—slowing down, adapting, listening. Every week at the farmers' market is an exploration of what it means to farm well and eat well in this specific place, to choose to farm and eat in ways that move past just sustainability, that actually leave the land healthier and more diverse for future generations. Our palates and fields will be informed by the flavors and traditions of newer waves of immigration from Asia and Latin America. There will be new discoveries and heirloom varieties rediscovered.

This is slow, healing work that will take many lifetimes to realize. It is impossible to say where those conversations will take us. But because this is a revolution based not on maximized production, but on taste and on intimate connections between growers and eaters and the land, I am confident in saying this: the future will be delicious.

We celebrate our role in this hopeful new future. Cheers to you, friends, and to the years of good eating to come!

—from Casey Letellier's toast at the 2015 Siloam Springs
Farm to Table Dinner at R Family Farm

Chef and restaurant owner Miles James acknowledges, "I think any book being written on our region is great."

"To me, cooking is the ultimate art form. When it all comes together—the sounds of searing meats and popping wine corks hover like mist in the valley—it's quite a rush."

—Chef Miles James, from his latest book, *Cuisine of the Creative*

OZARK BEGINNINGS

Northwest Arkansas begins in the Ozark Mountains. These rugged mountains are set apart from the rest of the Natural State, just like the rugged people who first called it home. Northwest Arkansas' early settlers lived in isolation for many years, carving out a plot to grow food in an unreachable and densely forested land.

Geographically, this region is known for its extensive forests of hickory, oak and pine, as well as highly abundant water resources, including swift streams, rivers and reservoirs. Here, surface rocks are older than those exposed outside the region, including dolomite and limestone, many of which house fossils from a time when the mountains were the guardians of an ancient inland sea, per author Harry S. Ashmore in *Arkansas: A History*. Geological evidence shows strata from these seas overlying the Ozarks from various periods of the Paleozoic era. With the close of this era, seas receded, and over time, erosion took its toll on the mountains, rounding them off to the Ozarks. The first Arkansas "hillbillies," or hill folk, found them a veritable never-never land of uncharted territory.

The decay of these rock formations left behind rich sediments of limestone, dolomite, shale, loess and alluvial deposits, creating a diverse Ozark soil. This soil could grow corn, a staple crop for man and his animals during early settlement days. Limited early crop cultivation in mountain valleys was supplemented by the many rewards of the Ozark forests: wild game, fish and the gathering of wild greens, nuts, fruit and honey, according to the *Encyclopedia of Arkansas*. Even the forests' abundance of hardwoods was an

immediate resource for log houses, which could be built in just a few days by not having to haul wood long distances. Ozark settlers could return home with the wild turkey, deer or squirrel they'd just hunted instead of waiting on resources to build a home or the growing season to eat a meal.

Over time, these mountain settlers learned to produce more of their daily needs, due to their isolation from other towns and transportation sources. Living in a primarily subsistence economy, nearly all pioneer families of the Ozarks grew whatever wheat, tobacco, flax, hemp and cotton they could for domestic use.

Natural wildlife in the Ozarks was so abundant that families could subsist on game alone if they so desired. For example, abundant wild hogs called "hazel splitters" or "razorbacks" roamed the woods freely, becoming a primary staple meat in the diet of early settlers due to its ability to be preserved. Other game such as squirrel, raccoon, rabbit and possum (which might be uncommon to find on a restaurant menu today) were plentiful and at the ready for any Ozark hunter's table, per author Milton D. Rafferty. One Madison County resident even said of the possum, "We put it in the pot and biled it; and then put it on and baked it." That's just one recommendation. Here's another one: "Possums! I should say so. Dey

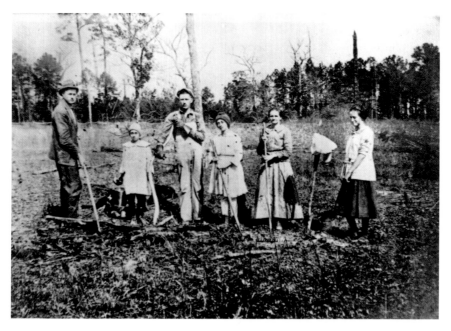

A typical Ozark family with field-clearing tools. *Rogers Historical Museum.*

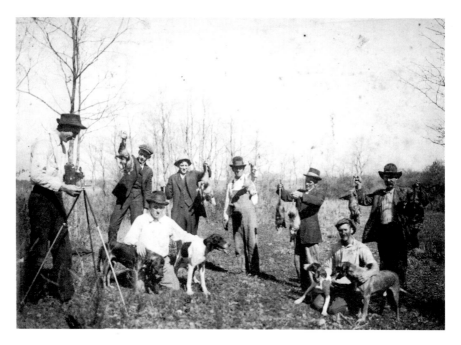

The great possum hunt in the Ozarks drew in two photographers to document its success. *Siloam Springs Museum.*

cotch plenty of 'em and after dey was kilt Ma would scald 'em and rub 'em in hot ashes and dat clean't 'em just as pretty and white. Oo-oo-oo but dey was good. Lord Yessum."

The rugged people of the Ozarks learned to work with what the land would give them, from its ample supply of wild game and forest fruits to what they could cultivate themselves in its rocky soil. The temperate climate ensured much could grow in its longer spring and summers than the neighboring territories to the north. Infrequent snows and killing frosts in late October and November also extended the growing season. People of the Ozarks largely relied on their own industriousness, as no major roads reached these parts, per Rafferty. For instance, in the Boston Mountains area of the Ozarks (south of modern-day Fayetteville), mountain gorges 500 to 1,400 feet deep were not uncommon for settlers to negotiate. Navigating the Ozark forests on foot or animal was difficult for any but the hardiest and most determined.

Many settlers came at the beginning of the nineteenth century to what was then known as the District of Arkansaw. This district was part of a new territory formed out of the lower parts of the New Madrid

district, formed on June 27, 1806, by the legislature from the Territory of Louisiana. It was officially sanctioned by an act of Congress in March 1819, and eventually admitted into the Union on June 15, 1836, as the twenty-fifth state. Even though President James Monroe established Arkansas as a territory less than a week into office as our fifth president, official recognition did not change the Ozarks' remoteness, with settlers coming and going. Traveling by land was an extreme hardship, as Arkansas was almost completely road-less. River traffic was only as close as the Mississippi River, on the opposite side of the state, and then the Arkansas River after 1820. According to Charles Morrow Wilson's book on the Ozarks, *Stars Is God's Lanterns*, mail routes were not established until the 1830s, with many outliers not before 1870. Stagecoaches were delayed also, with few even during the 1850s. There was a strong inability for the Ozarks to attract and retain settlers.

Per author Brooks Blevins, the Northwest Arkansas region itself became a natural backwater due to its historical and geographical location. Pinned in on the east by an impenetrable (at that time) labyrinth of swamps and dense forests, and on the west by dangerous Indian territory, these folks were blocked from the rest of civilization's development for some time. Factoring in the rough hills and rugged terrain it took for people, transportation and general culture to reach the Ozarks, it was set up almost naturally as a pocket or island unto itself. When other states were gaining railroads in 1850, Arkansas' Ozarks were getting their first roads (interstate) and telegraphs along "wire roads," per Wilson.

While the rest of the nation plowed their land with machines, well into the 1900s Ozark folk were still behind the horse and plow of a century earlier. Other sources also contributed to the Ozark "hillbilly" reputation and stereotype. The few visitors who reported back on the isolated Ozarks were often city-slickers unprepared for its wild way of survival in an uncharted wilderness. Henry Rowe Schoolcraft was one such novice. Largely from Schoolcraft, and possibly due to intimidation from his greenhorn abilities, Arkansas received an overall negative report back to the rest of the states. His journal entries are loaded with mention of a backward, semi-savage society populated by lazy, illiterate drunks. Those are fightin' words in these parts. However, Arkansas continued on despite its erroneous and exaggerated reports, according to historian Brooks Blevins. One such noted report details an author who continually complains of food, albeit free food, in Arkansas homes: "Every meal, where it be breakfast, dinner or supper...consists of the worst possible coffee, indifferent dirty frothy-looking butter, black sugar

An Arkansas boy helping the horses plow the farm. *Gail Brewer.*

or honey, as the case may be, a little bacon, or some sort of dried meat cooked, I do not know how, and as tough as leather, and miserably made Indian corn bread."

Another lamented, "The supper consisted of some pieces of dirty looking fried pork, corn-bread eight days old, mixed up with lumps of dirt, and coffee made of burnt acorns and maize; they had neither milk, sugar, nor butter." Not too shabby provisions for people who grew up poor, grew all they had and gave freely to a stranger. It seems a country boy truly can survive!

Henry Rowe Schoolcraft later changed his tune after experiencing the kindness of the Ozark folk, who saved his unprepared hide multiple times from starvation, exposure and death in the Ozark wilds. According to his journals, he later commented on the nearby White River Valley people that they were "hardy, brave, independent people…frank and generous," further commenting that these Ozark men "would form the most efficient military corps in frontier warfare which can possibly exist." According to Blevins, German-born Friedrich Gerstacker found the Boston Mountains of Northwest Arkansas to be the place of Rousseau's natural man, a solace from civilization. He lamented in 1842 upon his departure: "Of all I had seen in

America, Arkansas was the one which pleased me most; I may perhaps never see it again, but I shall never forget the happy days I passed there, where many a true heart beats under a coarse frock or leather hunting-shirt."

Of course, the true history of the region starts even earlier than these settlers with the *first* people who were found here during initial exploration. The name *Arkansas* originates with a Native American tribe, the Akansea, whom French explorers met in the 1600s while traveling down the Mississippi River to the Arkansas area, per author Ruth Mitchell. These people, later renamed the Quapaw, thrived in Arkansas until the 1750s, when contact with European smallpox and measles largely depleted their numbers. Eventually, the remaining Quapaw signed a treaty in 1818 with the United States, gave up most of their land and began moving west.

Their neighboring tribe, the Osage, lived and hunted primarily in Northwest Arkansas. Known as fierce hunters and a strong tribe, the Osage handled the outbreak of European diseases better than the Quapaw. Unfortunately, the tribe became overcrowded by the Cherokee tribes that were pushed out of their homeland from the east toward promises of a reservation for them in Northwest Arkansas. A constant battle between the Cherokee and Osage ensued in this part of the state, causing the United States government to create Fort Smith in 1817 to maintain peace and order

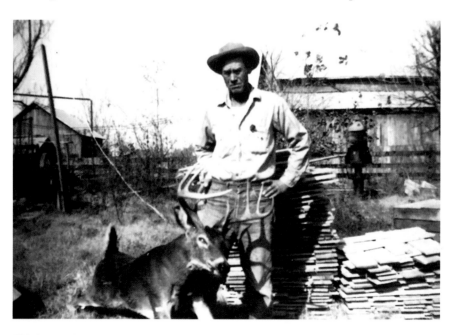

This hunted buck will be roasted, canned and dried for the Ozark table. *Gail Brewer.*

on the new frontier. Sadly, in 1825, the United States negotiated a treaty with the Osage, taking away all of their Arkansas lands.

Native Americans, like all people of the Ozarks, held a strong connection to the land as a food source. It was their hunting ground, a preferred place they also called home. Even travelers through Arkansas were touched by the kindness of Cherokee in blessing them with gifts of food. One instance of this was experienced by Cephas Washburn, father of Edward Washburn, who later painted the famous painting of *The Arkansas Traveler*. Recounted in the book *Arkansas Heritage*, Washburn and his men, in setting up his Presbyterian mission near modern-day Russellville, had to wait out a flooded creek, encountering hunger and exposure in winter, while traveling some distance from his mission. The Cherokee man and woman who took them in

> *gave us every hour or so, a mouthful of food (dried bear meat), giving us to understand this was all they had. After keeping this up for twelve hours they prepared for us a delicious meal….First a large pumpkin was peeled of its rind….Seeds were removed and the whole put into a large earthen wear pot. Next some beans….Last, though not least, there were eight pounds of smoked bear meat, a pure mass of fat, and not less than five inches thick, put into the pot. This was made to boil for some two hours, when the whole was poured into a large wooden bowl and we were invited to partake. This invitation was most joyfully accepted.*

Then as now, the Cherokee are known as a peace-loving and friendly people, not to mention intelligent enough to create their own language and resourceful enough to survive Ozark winters.

But winter and food supplies got tough on both Native Americans and Arkansas settlers in the wake of the Civil War. Archie Reed, longtime resident of Cane Hill, retells, "The Prairie Grove Battles reached us eventually and caused the first burning of the college (Arkansas' first) and a lot of bushwhackers that terrorized the countryside of Arkansas and its families. The South didn't have the equipment. It's amazing they lasted as long as they did."

In a series of letters shared by Lawrence McElroy, director of the Cane Hill Museum, the story is told of the Civil War burning, raiding and killings of 1864 in Northwest Arkansas. In the letters, Fannie Braly writes her brother Carrick, a Confederate soldier, about the happenings at Cane Hill, one of the Ozarks' earlier towns. In June of that year, her letters are more hopeful. Fannie states:

We did not raise enough corn to get through the winter, but Mother bought some corn and wheat. The feds did not take anything from us except to kill some hogs. I did not say much to them, though I can tell you it was hard to hold my tongue...but I thought it better to do that than to have them tear up the house and take everything we had....There is people in here every day from Benton County trying to buy wheat, corn and meat and I expect there are a great many families suffering, everything they had has been taken!

Times indeed were tough during the Civil War in Northwest Arkansas. As Fannie mentions Benton County suffering like her Washington County, the Samuel Peel family of Bentonville was undergoing raiding and starvation at the same time. According to J.B. Portillo, Peel Mansion Museum volunteer, Mrs. Mary E. Peel knew how to farm and tend animals, but like the Bralys, much of her food was taken by soldiers coming through. Mrs. Peel never forgot how hard it was in those days, such that after the war ended, she began storing everything in multiple cellars still beneath the Peel Mansion to this day, vowing her family would never starve again. Now a historical museum, it stands as a tribute and reminder of the hardships many Ozark families endured to survive. Another such family, the Andy Lynch family of Pea Ridge, Arkansas, owned a log cabin on the battle path in Northwest Arkansas. Missy Stratton, a Peel Mansion Museum volunteer, often tells stories on her guided tours of Civil War soldiers breaking into the Lynch log cabin to confiscate guns and ammunition from the women left behind. The Lynches cleverly hid their needed items under their skirts, and they remained unfound by the soldiers, who left empty-handed. Women needed those guns in the Ozarks for protection and to hunt their food. Food was scarce and farming was hard without the men around to do the heavy lifting. Animals that would normally be working on the farm were slaughtered out of necessity. Those kept alive had a hard time eating unless they were allowed to free graze; in short, food was scarce for all.

As the Civil War raged on, by November 1864, Fannie's letters took on a more somber, sad tone. She mentioned losing all their food and then watching the Fifteenth Regiment of Kansas burn her house on November 10, 1864. Once they had a roof to share with a neighbor, the Braly family mentioned having bread again, as well as hominy and baked apples. They had to kill their cow, Whiteface, which made a fat and "splendid beef." Fannie's mother watched her house burn and lost it all with "no pony to plow," causing her to consider moving south for the first time. "It isn't

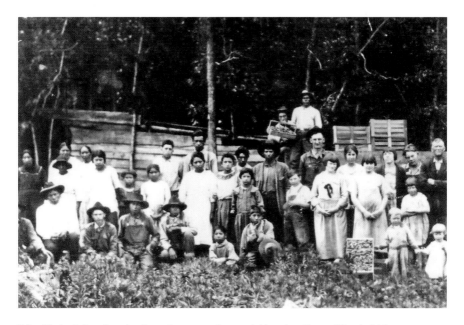

John Taylor's farmhands after a busy strawberry picking day. *Rogers Historical Museum.*

worthwhile to raise corn and have it all taken from us. The Lord only knows what will become of us if this dreadful war lasts much longer."

After the Civil War, Ozark folk again tried their hand at farming the sometimes rocky soil. When success came, it came in a flush, as apple orchards bloomed up around the countryside, supplying much of the nation's apples in the late 1800s. Peaches and corn grew well, as did tomatoes and grapes in some parts. Milton D. Rafferty's book *The Ozarks: Land and Life* reveals that huckleberries, strawberries, blackberries and sand plums all grew wild. People planted more. Ken Butler of Cane Hill notes, "You saved the seed of what you grew to plant next year."

Property first and foremost included the family log cabin, usually built on a hill by a spring, with fields in lowlands or creek bottoms. The earliest and most primitive cabin was one room with a dirt floor, a fireplace on one end and a sleeping loft under the roof. Author Nancy McDougal reveals that most cabins were put together at a neighborhood house-raising. Whole families arrived with axe-equipped men and women with food for the noontime meal. A long dinner table and benches were improvised for lunch. Fires were built so women could boil coffee and cook food, during which time they would catch up on the gossip. Women quilted when not

cooking, and children helped with mudding the logs together. At night, according to McDougal, "the completion was celebrated with a dance in the cabin [just built] during which corn liquor [moonshine] flowed more or less freely." One-room cabins often had lean-to kitchens added in later years. Once a pioneer had a house, next came the barn, corncrib, well, storm shelter, springhouse, smokehouse, ash hopper, fruit house, turnip cellar and some bee gums.

As Ozark folk worked the land, fought for it and then worked the land again, the nation elsewhere was collapsing. In the 1920s with the Great Depression, their simple way of life found its positive light in the media like never before. According to Blevins:

> *People lost everything and the Ozarks presented the non-materialistic, going-back-to-nature life that people were craving and remembering of their ancestors. Leftward-leaning writers found the Ozark life refreshing amongst the disenchantment of a modern life bent on consuming itself. They found these people of an original American soil, an antidote to the prevalent greed of America tucked away in the hidden Ozark hills.*

That secret is now out, as the relentless entrepreneurial and hardworking spirit that created it has flourished into something monumental, bringing notice to the little hidden pocket in the hills. People come from all over yearly to sample and even move to the Ozarks. But with an exponential explosion of people, that heaven might get destroyed if we're not careful. Red dirt piles onto what was once fertile Arkansas farmland to provide the base for numerous condominiums and apartment buildings in the Fayetteville-Rogers corridor. Land that is our heritage is being plowed under, and we're doing away with the opportunity to grow our own food in light of a growing population. A counterintuitive oversight is doing away with the land that makes it appealing; plus, something must be left to grow food for all these people. If farms go, we stand a very good chance that our food history or High South cuisine will fade out with it. People are already forgetting how to farm like their grandpappy did, and they have "done sold the land" they would have had the chance to work and plow. That land is rich, not just in soil but in heritage of our Ozark past. The early settlers wouldn't see us throw it so easily away to mount up buildings that tarnish our skyline and don't last more than a decade, per the opinion of this author and conservationist Rick Parker. What are we willing to lose? This book is not just a detailing of that change, past to present, but it's a love

story about Ozark cuisine, its ingredients and why it exists. It's a beautiful food heritage we'll soon lose if we don't save it now, by saving our land and our people's traditional way of life and heritage.

What Charles Morrow Wilson writes of our stories and heritage can also be applied to our food culture: "They are begotten not only by the earth, air, rain, and sunshine of this exceptional region, but by its ill-defended, almost miraculously enduring and invincible spirit."

We need to make it possible for people to make a living being farmers, growing food in the Ozarks, by supporting them with our grocery dollars. And it's not just the land we protect for them and our food; it's also a natural habitat for all the wonderful animals that call Arkansas home. We must share it with them and, like the first native Ozark folk before us, only take what we can use from them and use all parts in our cooking. It can be done. Our apathy or our addiction to convenience will only hasten the process of forgetting the land. There are still people who want to work it and grow our food, but they've "bet the farm," as the saying goes, and those generations will eventually age out, per conservationist Parker. Now it's up to those with financial and influential power to make the best decisions for our future, making their way of life possible again.

Inside these pages, you'll not only find unadulterated, timeless recipes but many others that process parts or whole animals you may never have considered trying. Squirrel isn't half bad, as it turns out. People lived on it for years; why can't we? Our excessiveness and wealth have left us out of touch with the wealth of nature. If we work to do what we can, perhaps the next generation will still get to try it. Ozark High South cuisine is more than just a selection of regional foods and recipes; it represents a way of life that made and can still make Arkansas a great place to visit and live, for us and the animals. A common thread uniting all of the stories of the Ozark people and recipes they wrote is a need to take nothing for granted. A need to appreciate and savor nature and God's bounty is poignantly felt.

According to Brooks Blevins, one New York writer noted that the people helping to construct Bull Shoals Dam as late as the 1970s still lived life "much the same as that of the pioneers who first settled here. They have barn dances, candy pullings, pie socials, box suppers, hog-calling contests, 'possum hunts…" Much has changed, but most at its core remains the same, and those are the things that people hold onto—the good stuff.

If we are what we eat, as the old adage states, the Arkansan must be a living representation of all that grows, swims, walks and flies over the Ozark hills. Since the early settlers, people have been hunting, fishing,

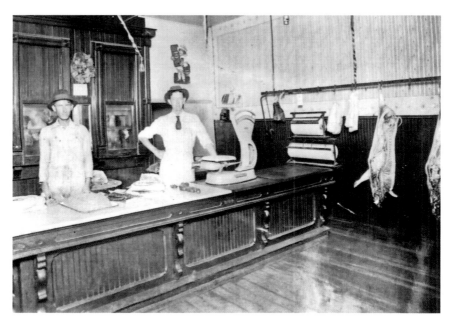

Juhre Meat Market, 1910. *Rogers Historical Museum.*

growing and gathering what the land served up, and indeed, it has been varied and plentiful, thanks be to God. According to the *Encyclopedia of Arkansas'* listings, we have a rich and varied diet with meat, vegetables, fresh water and clean air similar to what early settlers and current Ozark folk still find. Darn, if it weren't for our deep mountains and valleys, a lot more people would have found it sooner than now. So what are these things that make up early to current Ozark cuisine, what some call the High South style? Start with fresh spring water out of the limestone and add in all that grows near it: persimmons, poke sallet, watercress, dandelion weed, walnut and hickory trees with their nuts, lamb's quarter, wild morels, onions and berries. In the waters and fresh springs, fish out crawdads (our Ozark lobster), catfish, perch, crappie, some of the best trout you've ever tasted, bass, shad, frogs and striper fish. People aren't the only ones competing for this food, though, in the Ozarks. As long as the wilderness stays protected and appreciated, wild animals like bears can still forage and find fish; venison can still end up on the Ozark plate, along with possum, rabbit, squirrel and hog. It wasn't even uncommon in early settlement days to find bear served at a family home—a little greasy but sustaining nonetheless, per Blevins. Fowl was also abundant,

including wild turkey, chicken, quail, pheasant, an occasional duck and goose.

So that's the story, the foundation of the cuisine. Now we toss it up with a chef's perspective, mixing in some intriguing history, humor and sage foraging and hunting advice, garnished with a dash of cooking technique. Since the origins and way of life are better understood in the Ozarks, it's time to dig in to each ingredient, complemented by a recipe or two. Discover the unique Ozark dishes you never knew you could order, buy or prepare. Any ingredient, especially Ozarks' own, can be transformed into a life-affirming dish, full of its own history and recipes perfected over time, so rich you can taste it.

CORN

At the first sound of the whippoorwill in the spring,
the Indian knew it was planting time for corn.
—Frances Lambert Whisler

Whatever Native Americans took the time to plant, it would need to be something highly valuable. Corn, likewise, was one of the first things Ozark settlers learned to grow. Its many purposes coincide with its many types. What kinds of corn are out there? According to botanist Amy Stewart, there are at least seven types common to this country: dent, flint, flour, pod, pop, sweet and waxy. Dent (also called field corn) is the most widely grown type in America, a preferred type to make hominy and grits. Flour is just like it sounds, becoming corn flour, best known as meal or cornmeal. Pop corn just requires putting the two words together. Just in case you were wondering why popcorn pops, its large endosperm explodes when heated, essentially turning the grain inside out. Sweet corn is best when on the cob, as well as in moonshine.

The legend of corn or maize, according to Indian folklore, is that the Great Spirit showed the wise forefather of all Indians the plant corn. He was instructed to preserve two ears on the plant until the next spring and plant the kernels. He would preserve the whole crop and send two ears to each of the surrounding Indian tribes, with the premise that they would not eat any of it until the third crop. This is how corn was distributed to all tribes of American Indians, according to folklore, per author Frances Lambert Whisler.

Historically, the Indians of the Ozarks would have eaten corn and its byproducts in their diet. To dry corn in order to preserve it, the cookbook *Indian Cookin'* recommends flint corn. Native American hunters, including the Osage and Cherokee, would have carried parched corn on the hunt, wrapped up in pieces of leather, as it would provide enough sustenance to live on for several days. Cooking cornbread while traveling, Indians could break bark off a nearby tree, preferably chestnut, and cook the dough inside it near a hot fire. Ash cake also was a simple recipe for cornbread made in the ashes of a fire. Try it over a campfire or in the winter when the hearth fires are burning.

Ash Cake (from *Indian Cookin'*)

2 cups cornmeal
¾ teaspoon baking soda
1 cup buttermilk
⅓ cup fat
enough water to make a thick dough
salt to taste

Mix all dough ingredients together in a medium bowl. Make a hole in the center of ashes of a hot fire—rake down to hearth—place the dough in the hole. Let it make a crust and then cover bread with hot ashes and embers. Bake till thoroughly cooked and lightened.

Why plant corn? Botanist Amy Stewart states that early settlers quickly realized corn was one of the easiest grains to grow in unfamiliar terrain, a fact that they learned from local Indian farmers. Corn could be planted around un-cleared tree stumps, thus enabling it to break ground sooner than other crops. As a bonus, planting a cornfield established a land claim for early settlers. Some southern states' early land grants were completely contingent upon either building a structure or growing corn.

Corn, like many crops, had farming and planting times influenced by weather, per author Nancy McDougal. One old Ozark farmer said, "Well, when the moon is full that's the time you plant the stuff to grow on top of the ground. You plant corn and cotton, watermelons then. They grow larger."

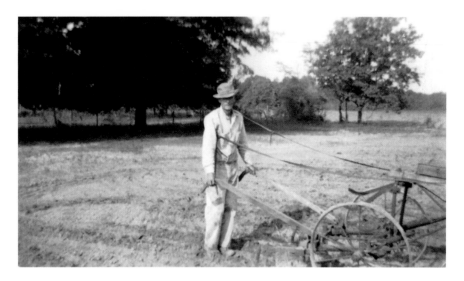

Preparing to plow the soil. *Gail Brewer*.

Perhaps this tip guided Arkansas farmer George Osborne, who grew the world's tallest stalk of corn in September 1937, measuring in at nineteen feet, two inches, challenging an Iowa champion of eighteen feet. This part of the Ozarks received national recognition for it, grown about six miles outside Siloam Springs, according to *Garden Sass*. Corn doesn't grow that tall without the right soil and care. People love their corn in the Ozarks. If looking to join the corn-growers, just note that corn is also a weather signal, much like persimmon seeds; if corn shucks are thick and tougher than ordinary, expect a hard winter to come. They say the same thing in the South about animal coats, seen on horses and cattle. Nature has a way of preparing itself. The best thing people can do is have a roof over their heads and know how to cook and grow their own food. This book can help with the last two. You're on your own for the first one!

Once a farmer had fenced in his land, he could begin the plowing process and start to grow corn; even today, most farmers still have a corn patch in the side yard or mixed in with the flower beds. According to the book *Garden Sass*, this food was eaten at every meal, in its many versatile forms. Corn can be cooked on the cob, called "roasting the ears"; cut off the cob to make hominy, which later can become grits; or ground to make cornmeal (used for cooking corn pone, cornbread, etc.). All parts were used, as stalks could feed animals and cobs became dolls, torches, pipes and even jelly. Shucks were

cut into strips to make brooms, mattresses and shoelaces; braided to make hats and horse collars; woven into chair seats; and even studied to predict the weather. George House recalls, "People even would roll up corn silks and smoke them!"

Nancy McDougal states that in the 1900s, corn was the chief feed crop, while cotton was the king cash crop all over Arkansas. It was a farmer's sole means of making money. Even tenant farmers would rent land "on the third and fourth," meaning they'd give the landlords a third of the corn and a fourth of the cotton. Corn was probably one of the more valuable food sources as well as living materials for the early pioneer due to its versatility. When men were fighting in the Civil War, one storekeeper recalled women of the Ozarks hiding their valuable seed corn in large bored holes inside walls. They would cover them with a peg and know that they would have a crop again the next year, effectively saving their food supply. If they had not hidden it, jayhawkers and bushwhackers who destroyed and pillaged the mountains would have taken it.

Taking fresh-grown corn and grinding it to cornmeal was a process. The ears must first be roasted on the wood cooking stove or fire, shelled and then taken to the neighborhood mill. From that cornmeal could be made

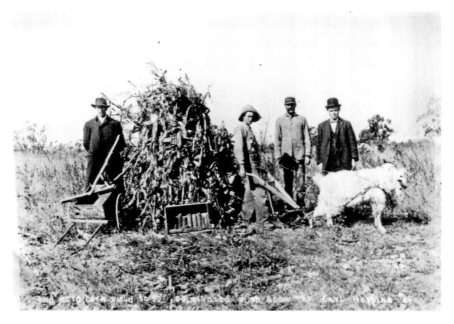

Earl Hopping's one-acre cornfield cultivated by a goat. *Rogers Historical Museum.*

After the corn harvest at the Farley Farm, mid-1900s. *Rogers Historical Museum.*

cornbread, corn pone and corn mush. The neighborhood water mill was a valuable necessity in the Ozarks. Not only would you go here to have corn and grain ground for making food, but it also was a social gathering place since houses were far apart. It served as a site for baptisms and the voting place on election day, according to McDougal. Additionally, many mills used their water power for making thread, carding wool and even distilling liquor. In Van Buren County at the Hunter Mill, corn could be ground or liquefied as one desired. If water power was low, the mill always ground corn and food first and then took care of other water power uses. The mill was so important that many towns of the Arkansas Ozarks still carry their names—just look at War Eagle (named for its still-operating gristmill), Johnson (named for the family that owned the Johnson Grist Mill) and Dutch Mills.

If corn wasn't ground into meal, it often took on the form of hominy in early years. Hominy was introduced originally to American colonists by the Native Americans. It is a hulled corn with kernels removed through many soakings in a weak lye solution. It's very good, although a bit difficult and time-consuming to make, but a true Ozark food of our ancestors, per *Indian Cookin'*. It's also popularly ground into grits. Now it doesn't take true grit to make or eat these, just an empty belly, because they will fill you up and are

great at breakfast or served alongside meat or shellfish. Hominy is wonderful used like corn in a cheesy casserole or simply as is. It's a little trickier to find fresh, but when you do, buy lots and store it up.

This author was privy to meeting a true Ozark cook at the Cane Hill Harvest Festival, still hand-shelling and stirring up hominy in a huge black kettle. Carolyn Latta was there to show others the old ways. She still uses her old cellar from the early 1900s and cans most of the food grown in her garden and the wild game her family hunts, all to ensure food throughout the winter. According to Latta, to make hominy,

you start with two kernels of field corn (I prefer Hickory King variety) and put them in the ground about eighteen inches apart. You don't plant field corn too close together like you do your sweet corn because it's gonna stay in the ground a lot longer, from May when you plant it 'til September or October. You don't harvest it green, but when it's dried out on the stalk; a lot of times it will be broken down and hanging. You gotta let it dry after harvesting because it won't go through your sheller and it can't be ground for cornmeal either. You're gonna shell it to get the chaff out of it—you know it talks about that in the Bible—we're gonna take the good stuff, our corn,

Chef Kurt Plankenhorn's Creamy Stone-Ground Grits

If canned hominy is then dried and ground, it becomes grits, featured in this dish by Chef Kurt Plankenhorn of 28 Springs Restaurant, Siloam Springs.

3 cups cold water
1 teaspoon kosher salt
1 cup stone-ground white grits (War Eagle Mills preferred out of Rogers)
½ cup heavy cream
1 tablespoon roasted garlic

Bring water and salt to a boil. Pour in grits and stir until combined. Turn heat off and allow to rest covered for 20 to 30 minutes. Add heavy cream and roasted garlic. Adjust seasoning as needed (with salt and pepper).

and separate it from the chaff and put in a big pot (per gallon of corn), adding two heaping plastic teaspoons full of sodium hydroxide. That's food-grade lye. Put that in your kettle and cook it down with lots and lots of water for about two and a half hours; it's gonna be real syrupy. Wearing gloves, dip corn out and run through about five separate rinses in enamel pans before returning it to the kettle. We rinse out our kettle too and put the lye water back in with some fresh water. We'll do this process again. Our water won't be as murky after this, because most of the lye has been cooked and rinsed out of it, and then we'll rinse it again and start canning.

Johnnycake

Other early southern dishes like johnnycake, hoecake and shortenin' bread were originally cooked over coals in the fireplace. Sing this rhyming folklore recipe for johnnycake, traditionally made on the hearth but adapted for the oven. Just note in the recipe: a big spoon equals a tablespoon, small spoon is a teaspoon and Indian indicates cornmeal. Place batter in an 8x8 pan or greased cast-iron skillet and bake 40 minutes or until done at 400 degrees.

Two cups Indian, one cup wheat
One cup good eggs that you can eat,
One half cup molasses too.
One big spoon sugar added thereto,
Salt and soda, each a small spoon.
Mix up quickly and bake it soon.

Hoecakes (by Gail Brewer)

Hoecake originally was so named because it was baked over open fires in the fields on a hoe blade by southern slaves. Today, the term may indicate small fried hoecakes (made on a cast-iron skillet, not a hoe), as well as a large biscuit made traditionally for the man of the house.

¼ cup oil
1 ½ cups self-rising cornmeal
¼ teaspoon baking soda
1 ¼ cups buttermilk
1 egg, lightly beaten
1 tablespoon shortening, melted

Heat ¼ cup oil to 365 degrees in a heavy skillet, cast iron preferably. Combine cornmeal and baking soda in a medium bowl. Add buttermilk, egg and shortening. Stir just until dry ingredients are moistened. Pour ¼ cup batter into skillet for each hoecake. Fry 1 to 2 minutes until golden brown on each side. Add additional shortening if needed. Drain on paper towels. Serve immediately.

*They cook by the fireplace with a skillet and a lid.
And all live on black coffee, sow bosom and cornbread.
All are free-hearted and respect the moral law
Is the reason that I love to live down in old Arkansas.*
—*Marion Hughes in* Garden Sass

Cornbread

This is absolutely the best I've had anywhere and is made traditionally without a recipe, but Gail was kind enough to try to measure it out for the first time, ever!

¼ cup vegetable oil
2 cups self-rising cornmeal mix
1 cup self-rising flour
1 egg
1 tablespoon sugar
3 cups milk

Heat 3 tablespoons oil in cast-iron skillet until hot on inside of pan and along sides (warm during oven preheating to 450 degrees). Meanwhile, mix remaining oil and all other ingredients. Pour into hot iron skillet and bake at 450 degrees for 25 to 30 minutes, or until golden brown. A knife inserted in the middle should come out clean if you're unsure. Immediately invert onto a plate from skillet and cut into squares. Serve piping hot with butter or sorghum.

If you want to adapt Gail's recipe to make Cracklin Cornbread, the way her granny taught her, just reduce the oven temperature to 425 degrees (same cooking time), use melted butter instead of oil, add 1 egg, use ½ cup self-rising flour, 2 ½ cups buttermilk and add 1 cup cracklins. (Cracklins are fried pork fatback that are just crackly and delicious, similar to bacon.) To make them, just gather up 2.5 pounds of cracklin fat (thick fat with some meat through it on a hog). Cook this in a pound of hot lard until the meat has been rendered of its fat and rises to the top of the pot. (You may want to do this outside because it will smoke a lot.) Drain out the cracklins on paper towels or grocery paper sack. Serve cracklin bread with honey or apple butter.

Now, food like this wasn't always plentiful in the nineteenth century, per *Arkansas: A History*. One Arkansas visitor came to write about such an experience he had while visiting the isolated area in his song "The Arkansas Traveler." One lyric reads:

He fed me on corn-dodgers as hard as any rock.
My teeth became all loosened, and my knees began to knock.
I got so lean on sage and sassafras tea that I could hide behind a straw.
Indeed I was a different man when I left Arkansaw.

Corn Pone (aka Corn Dodgers)

hot water
2 cups cornmeal
½ teaspoon salt
meat drippings

Add enough hot water to make cornmeal and salt mixture stick together. Shape pones (or triangular pieces) between your palms, leaving prints of your fingers in the batter. Top with meat drippings and bake until done in a 400-degree oven, or fry pones until brown and crusty, about 20 minutes.

Cornmeal itself is such a diversely used food in southern cooking, particularly the High South cuisine of the Ozarks. Here you can fry fish in it, make hushpuppies or make some good old-fashioned corn pones or cornbread. In the south, white cornmeal is preferred, while yellow cornmeal is more common in the northern United States. Either way, both are readily available. Places like War Eagle Mill of Rogers are still grinding and selling it at their old-fashioned gristmill, much like in days gone by. Stop by to see it in action next time you're in the neighborhood. Cornmeal is one ingredient no Ozark kitchen can be without—ever. Make this next recipe to see why next time you catch a mess of fish.

Randy Brewer's Hushpuppies

Traditionally served with fish, these are a great use of leftover cornmeal batter to get hungry folks and pups to hush up already!

¾ cup cornmeal
¾ cup water
¼ cup milk
½ tablespoon vegetable oil or lard, melted
1 egg, beaten
½ cup flour
2 teaspoons baking powder
1 teaspoon salt
½ teaspoon sugar
1 teaspoon grated onion

Cook cornmeal and water about 6 minutes over low heat in a pan. Remove from heat, add milk and oil and stir well. Beat egg in a large bowl separately and gradually add batter to beaten egg in bowl, beating in. Blend in remaining dry ingredients and onion. Fry completed mixture by the teaspoonful in oil, 1 inch deep in a frying pan or skillet. Each hushpuppy should take about 6 to 7 minutes. Drain on paper towels and serve hot.

Corn has been on the Ozark menu for so long that it's bound to have some tall tales develop around it. George House tells, "When I was a boy, having a mule was like having a brand-new tractor. So when Daddy went fishing, I decided I'd plow a field with it. The mule wouldn't move though, so I knocked it between the eyes and killed it. I thought I'd never know what to tell Daddy. Well, I went to church that next day and decided what I'd tell him happened. So I told him I took him to the cornfield and darn if it got so hot that day that the field started popping and the corn became popcorn. The mule thought it was snowing, and he froze to death!"

So the next time you get some corn popping, think of George and make some delicious popcorn balls.

Debbie Rowe's Popcorn Balls

I can still recall my mom making these for Halloween, birthdays and Christmas. Make it your family tradition. Just roll up your sleeves and butter those hands!

½ cup brown sugar
1 ½ cups white sugar
1 ½ cups water
½ teaspoon salt
¾ cup corn syrup
1 teaspoon vanilla
3 drops food coloring, any color you like (optional)
popcorn, more than a gallon, hot and crisp, unbuttered and unseasoned,
popped in air popper or on stove

Combine in deep pan all ingredients except popcorn and cook to 260 degrees for hard ball stage. Pour immediately over popcorn slowly in an open pan or baking sheet, using spoon quickly to distribute syrup before it hardens. Butter hands (of you and a few friends) and form into 15 to 20 balls about the size of an orange. Let cool on wax paper.

*An alternate version of this would be to follow the same instructions using about 6 quarts popped corn and 2 cups molasses (or sorghum) combined with 4 tablespoons butter. The molasses is your complete syrup and flavoring; no need to color. The molasses will harden at 260 degrees like the above syrup mixture, so move quickly to make balls. This version makes about 2 dozen popcorn balls.

Cooking corn isn't difficult, especially if it's fresh on the cob. When you're buying corn, look for fresh, soft corn silk emerging from the husk, not dried or browned kernels. Buy more than you need; people just can't resist corn on the cob when it's on the table. Get a large pot big enough to hold all the

shucked cobs you have and get water boiling in it, add cobs and then turn off the stove and cover it for fifteen minutes. The corn will be hot and tender, ready to serve with butter, salt and pepper. A nice variation is butter, fresh minced basil and parmesan.

Now you *can* have too much of a good thing. Interestingly, an exclusively corn-based diet can cause pellagra, a dangerous and even fatal vitamin B deficiency, according to botanist Amy Stewart. But eating corn in combination with sorghum actually prevents pellagra. Sorghum grows in many of the same places corn can grow and, even more so, survives drought, famine and poor soil. In short, if planting corn, it would be wise to plant a patch of sorghum nearby. And like corn mash, sorghum mash can also be converted to a type of whiskey or moonshine.

So how does liquid corn like whiskey and moonshine fit into the Ozark hand of things? Like a glove. One article noted by Brooks Blevins read, "Farmers spent most of their time converting their corn crops into liquid form." According to historian Nancy McDougal, most towns had a distillery and a saloon. Until recently, many Ozark counties were dry. Back in early settlement days, saloons were on the outskirts of town due to the "three-mile law," which wouldn't allow liquor sold within three miles of a church. Most of the saloon whiskey came from the local moonshiner. It was wise to not

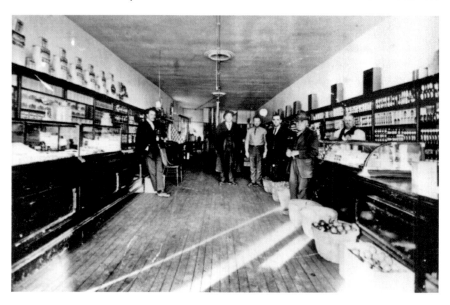

Moonshine was definitely absent from the shelves of Edwards Grocery in Rogers, especially in 1924. *Rogers Historical Museum.*

know where or how he got his liquor. Even if you stumbled upon a whiskey or moonshine still, it was best to "not see it." One farmer told of some advice his parents received in 1903 after moving to Arkansas: should they ever stumble upon a still, the worst thing to do would be to get scared and run. They were advised to be a part of it by stirring the mash and tasting the drip so as not to be a threat to its distiller. The idea was that if they helped with the whole thing, they wouldn't prosecute.

Mr. Cotton's Arkansas Moonshine

One old-timer recalls being a young man, brewing corn mash in a still for extra money: "We made eighty gallons a day [of moonshine] working for Mr. Cotton. We had a big copper pot that I would crawl inside and clean out that held the stuff!" Moonshine goes by many names, such as white lightning and mountain dew. Here's the recipe and chemical process he still can recall from the early 1920s, when he made it daily.

50 pounds sugar
50 pounds corn chops (can find at a feed store,
consists of corn pieces and stalks chopped up)
35 gallons water

Take a 50-gallon barrel and add in sugar and corn chops. Add about 35 gallons water (up to the first ring on the barrel, as he recalls). Let it sit seven days, stirring well two times per day. After seven days, the liquid should be clear. (To keep the liquid warm, place a piece of tin around barrel and place sawdust between tin and the barrel to insulate.) Cover when not stirring. Distill the alcohol to desired alcohol level through copper wire and heating. This mash should make 5 to 6 gallons of moonshine.

Razorjack: a variation with raisins, add 50 pounds until above moonshine colors

Peach Brandy: add 20 pounds peach puree after above moonshine is pulled from still

The distilling process involves heating the liquid for seven days once clear in the copper pot until it produces steam. This steam should be captured by a copper wire running across the top of the barrel to another pot with cold water. The copper pipe (or worm) must spiral downward into this latter pot filled with cold water, through which the steam condenses back to liquid and drips out into a pottery crock. Those drippings are moonshine. To alter the alcohol proof, keep distilling to get a lower proof. Should you wish to pour this moonshine into a wooden barrel (insulated by sawdust), you can then distill longer to make bourbon whiskey. Copper pots and wires are best when making moonshine, as copper is a good conductor and allows heat from the steam and subsequent cooling to react quickly, allowing for proper distillation.

In some places, moonshine is now made legally. While homemade white lightning cannot be sold, it can be traded. Now that just sounds downright neighborly! As Brooks Blevins acknowledges, "Nothing says hillbilly quite like mash and a copper worm."

Moonshine: often drank and brewed, rarely photographed. *Gail Brewer.*

Furthermore, the backwoods Ozark stereotype peaks with a symbol that still holds in the national consciousness: that of the "Arkansas Traveler," a painting, play and fiddle tune suggesting lowly and humble origins of the state. For example, one line of the dialogue of the play goes:

> *Traveler: Have you any liquor?*
> *Native: Naw, we ain't. The old hound got in the shanty, an' lapped it all up out'n the pot.*
> *Traveler: I don't mean pot-liquor, I mean corn liquor. Have you got any whiskey?*
> *Native: Naw. I drinked the last of it this mornin'.*

CANNING AND PICKLING

Canning and jelly-making is hard work, but Ozark folk have always been up to the challenge, harvesting the end of the garden and fruit season into rows of canned good for winter meals. Now we have deep freezers, but it still wouldn't hurt to have a cellar or pantry. Canning is not an art with a shelf life, you know?

The basic premise of canning, according to the *Nyal Cookbook* of 1916, involves washing, stemming and coring well-ripened (and often plentiful amounts of) fruit. These goods are placed in a kettle with as little water as possible to prevent scorching. Next, fruit is simmered until tender and then pressed, letting the juice drain out. Juice is used just for jellies, often matched cup for cup with sugar, while preserves and jams use more of the whole fruit. Pickling fruit is possible and involves an acid, usually vinegar, but is more common with vegetables because it imparts a sour versus sweet flavor.

Preserves, jams, jellies and pickles answered the problem of excess fruit and how to enjoy the garden year round. Germs that spoil fruit cannot thrive and multiply within the confines of a heavy sugar syrup or strong acid; thus, "preserves" are aptly named, as they keep fresh fruit flavors from its susceptibility to spoilage. When all germs on and within food are destroyed, it keeps for a year or longer through a process called canning. When making preserves, jams, marmalades or jellies, keep in mind that such articles need to be sealed in airtight jars. About three-quarters to a full pound of sugar will be needed for each pound of fruit; thus, the finished product is typically sweet.

Men picking Ozark summer squash for canning. *Rogers Historical Museum.*

When canning fruit, sugar is not a necessity like jams and preserves; however, the airtight seal is absolutely vital to ensure the longevity of the canned item. Often, fruit canned without sugar will have a fresher flavor when recooked later into pies or puddings, allowing the sugar instead to be added later in the final stage of cooking, according to the *Nyal Cookbook.*

Jelly-making, as a general rule, is a slow process where soft fruit is placed in a saucepan, crushed and left to heat slowly. Firm fruit, like apples, must be cut and peeled into quarters and then covered with water to cook down. Juice is strained from the fruit mixture, and often a second pressing of the fruit allows for a second quantity of jelly. For each cup of fruit juice, add a cup of sugar. Sugar can be heated in a pan and then added to juice that has boiled twenty minutes. Stir until the hot sugar is dissolved in the boiling juice, allowing a few more minutes' boiling time. Test for jelly consistency—if it gels on a spoon or between fork tines, it's ready. Turn mixture into glass pint jars, then set on top of a folded cloth inside a shallow pan of boiling water. This will finish the process. Remove from the water and cover with a clean towel until cool enough to place lids and rings on the jars. Often, the jelly will set as soon as it boils after the sugar is added. This is the process for any fruit jelly and can be applied to any type of fruit. Paraffin wax is an old-fashioned way to seal jars. Drop a piece of it in washed jelly glasses, and when the hot jelly is poured over it, the wax will automatically float to the top and seal off the jelly. If for one reason or another your jelly won't set, just remove lids or paraffin from glasses

and set non-setting jelly glasses in a pan of water and place in a 200-degree oven for one hour. Remove from oven, let cool and reseal.

It is recommended when canning, pickling or making any sort of preserves that all jars, lids and bands are sterilized in boiling water first (to prevent any bacteria or germs from ruining the food inside). This is definitely wise to do, per cook Carolyn Latta, as sometimes spoilage can result in explosions of canned food—not a pretty pantry picture, and what a mess! To ensure the hard work and garden goodies aren't lost, sterilizing can be done in a large pot on the stove or by placing jars right side up in the dishwasher and pouring in boiling water from a kettle to save time and do many jars at once.

According to Carolyn Latta, home canner:

> *The whole idea of pressure cooking is heating up items through pressurizing and eliminating all excess air so that your food can last longer. That's the commonality with canning: eliminating air to preserve food. Use a damp towel to make sure there is no food or salt residue at all on the rims or sides of the jar where you'll be creating your lid seal, as this can introduce bacteria or allow a tiny air gap to contaminate the food. This may seem like a meaningless, tiny step, but it is so important. You can feel it with your hand to make sure no food is there or any cracks in the jar (which is another thing to watch out for). If your cans don't seal properly, you will have rotten food eventually. Screw the bands on, just hand-tight. Wait twenty-four hours before you remove the bands. You'll know your cans are sealing when you hear the reassuring reward of a small "pop" sound, which gives a real sense of accomplishment to the canner.*

A word to the wise: be sure to read and follow all safety instructions if using a pressure cooker. If not used correctly, they're pretty darn dangerous. If used correctly, they really speed up the process, allowing for more jars per batch of canning versus stovetop canning in a water bath. If you do fall in love with the world of canning and pickling, it wouldn't hurt to invest in one of these time-savers.

Canning and pickling is one practice that hasn't changed much from the early settlement days of the Ozarks. As a process alone, it allows for food to be saved without refrigeration, a much-needed practice for survival for Ozark folk. Canning is a process that all should learn, as it helps us appreciate and not waste the bounty derived from a plentiful trip to the grocery, farmers' market or garden. Don't waste; pickle, preserve, jam, can—it's for your own good!

An Ozark strawberry harvest worth neighing about! *Rogers Historical Museum.*

Debbie Rowe's Strawberry Preserves

Canning Method: Boil 2 cups sugar and 1 cup water until water spins a thread, then add 2 cups strawberries, capped and sliced. Let this mixture boil 10 minutes, then add another 2 cups sugar and 2 cups strawberries. Let this sit until the next day. Then pour into jars and cover with paraffin or lids.

Freezing Method: Blend together in blender 4 cups capped and crushed strawberries and 4 cups sugar. Let sit for 20 minutes in a bowl, stirring often. Boil separately for 1 minute, 2 cups water and 2 packages pectin. Remove from heat and add berry and sugar mixture, stirring 3 minutes. Pour in sterilized jars or plastic bags once cooled. Store in freezer to finish the process. Keeps all winter.

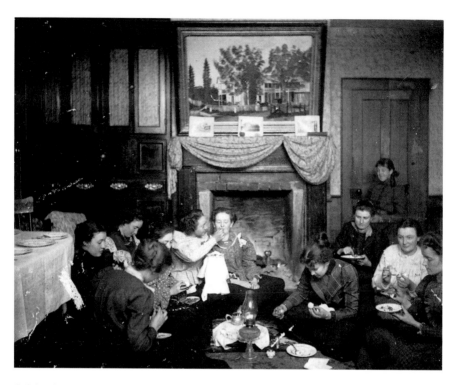

Celebrating with homemade strawberry jelly, toast and eggs at the Gunter home, 1895. *Siloam Springs Museum.*

Hard to find on grocery shelves, elderberries are a wild fruit native to the Ozarks that exist as a sort of hedgerow bush. Their tiny clustered berries are ready when they've lost their white blossoms and turn a blackish-purple.

Jessie Lanphere's Elderberry Jelly

Remove large stems and leave tiny ones from fully ripe berries. Crush and heat gently until juice starts to flow, then simmer, covered, for 15 minutes. Drip the mixture through a jelly bag or fine strainer. Measure 3 cups juice, then add to it ¼ cup lemon juice and 1 package pectin, boiling 1 minute after 3 cups sugar. Repeat proportions and process with any remaining cups of juice. Ladle jelly into glasses and seal.

Many folks do not understand how much vitamin C and nutrients are in a rose hip (the hard red berry on a rose), but early Ozark folk did, making this jelly a part of High South cuisine. Find rose hips in your garden after a good frost or even on wild roses.

Jessie Lanphere's Rose Hip Jelly

You'll want a granite, enamel or glass kettle or pot to make this jelly in. Roses and hips are reactive in metal, much like tomatoes. Gather a pound of rose hips after a good frost, mash and place in kettle with 1 cup water, boiling until tender. Run mixture through a fine strainer because seeds are very tiny. Wash the kettle or pot and place pulp back into it, adding 2 cups sugar and boiling until jelly sets (do one of the tests mentioned for jelly making above). Ladle into jelly jars and get ready for a vitamin punch to your morning toast! Rose hips, according to Ozark folklore, are a cold preventative during flu season.

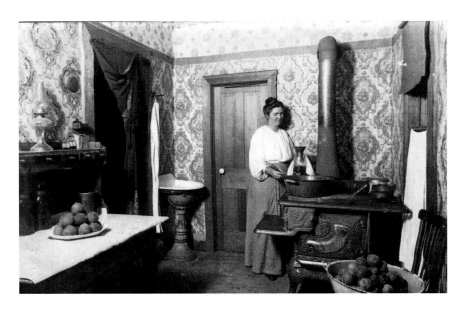

Making Ozark peach preserves at home. *Rogers Historical Museum.*

Most Ozark folk never needed to open a can of anything until winter, as the garden provided a continually changing bounty by eating in season. This might mean fresh tomatoes in summer only and strawberries three times a day for six weeks in spring, as well as apples, peaches and watermelon at different months of the year. Watermelon in particular was a respite in the summertime garden. After its harvest in steamy July and August, Ozark folk could enjoy a cooling fruit snack that fed a crowd. Easy to grow in the garden and also great to include in drinks and smoothies, the watermelon is a blessing. "I remember Grandpa putting half a watermelon before us, and he was so proud of their perfection," recalls homemaker Wanda Biggs. "Now I know how amazing it was [to pick that perfect melon at just the right time] because this summer I picked them early or too late, never having a perfect watermelon. You have to thump them and hear a hollow sound, and the little curlicue has to be dying on the vine." Available nowadays seedless with red or orange flesh, watermelons provide a great rind that should never be tossed but pickled.

Watermelon Pickles (Adapted from *Ma's Cookin'*)

This recipe can be adjusted to less, as it starts with 10 pounds of rind, which you might have only after a family picnic. And if you're using other people's rinds besides your own, don't fret; they will all be sterilized in the pickling process.

Take 10 pounds of watermelon rinds and boil them in water to cover till tender. Drain water off and set rinds aside. In same pot, boil syrup of 2 pounds of white sugar, 1 quart of vinegar, half an ounce of cloves and one ounce of cinnamon. Pour this syrup over rinds at boiling hot temperature for 3 days in succession, reusing the syrup and refrigerating between days. Then pack rinds into jars on the third day, top with syrup to an inch from top, sterilize and seal jars. Watermelon now is available outside of summer...well, at least the part that usually gets thrown out. Talk about economy!

Food has memories, even very meaningful ones, such as those of Almeda Riddle of Heber Springs, who recalls the fantastic tornado on Thanksgiving Day 1926 that took her home, husband and baby, as detailed in *Garden Sass*:

I never open a jar of apple jelly that is clear and red and beautiful that I don't think of my husband, even though it's been over forty-five years since his death. On that Thanksgiving morning we had just finished breakfast and the family had eaten up the last of a jar of apple jelly. My husband was sitting at the breakfast table holding our baby, we called him C.C., and he started pestering me to open up another jar of apple jelly. I told him I wasn't a-gonna do it because there was just one jar left and if I opened it there wouldn't be any left for Christmas. He kept on and on a-pestering and finally he started bouncing C.C. on his knee saying, "C.C., tell your mama that she'll have apple jelly for the rest of her life, but she may not always have you and me." I told 'em they were trying to play on my sympathies and I didn't have a bit of sympathy for either one of 'em; but I got busy and fixed them some more hot biscuits and opened that jar of apple jelly. I can still see them sitting there enjoying it and the way that baby's face looked so happy over that apple jelly. Right after that the tornado came and took them away from me (that very day) and I have been so glad that the rest of my life I haven't had to live knowing that I hadn't opened that jar of apple jelly.

Apple Jelly (by Gail Brewer)

2 pounds apple pulp (peelings, cores, apple pieces)
4 cups water
juice of 1 lemon

To simply make pectin, boil above and press juice through cheesecloth. Strain through flannel bags. Store in sterilized jars. Apples, as well as cherries and plums, have their own natural pectin, so no store-bought pectin is needed when making jellies and preserves with these fruits.

To make jelly, use all parts from apples. Cover apple pulp with water and cook until fruit is very tender. Strain twice. Return liquid to the heat and boil. Add ¾ cup to 1 cup sugar to boiling juice. Boil rapidly to jelly stage, stirring frequently (consistency to coat the back of a spoon). Pour into sterilized jelly glasses/jars.

Early Ozark settlers had fruit houses to store their fruits during winter and keep them from spoiling, according to Nancy McDougal. Usually hollowed out of a hillside and supported by logs and rocks for structure, its underground status kept fruit cool. Later, fruit houses were built like cabins with ample shelving for canned goods, platforms to hold dried vegetables and a roof hole to let hot air escape.

Leather Britches (Dried Green Beans)

Another way to preserve foods is to dry them, much like you could for green beans, per *Garden Sass*. When hung out to dry, Ozark folk called them leather britches, because they resemble pants drying on a line. To make them, stem and snap a mess of green beans into short lengths and spread out in a thin layer to dry. Turn them often to keep both sides drying. Leave them whole and thread a string through the beans at one end and hang them up to dry all together inside or out. Store in an airtight container once dried. To cook them once dried, just soak overnight and drain off water in the morning, covering with fresh boiling water and any meat scraps (like bacon or pork) on hand. Simmer until tender, which takes most of the day, so a Crockpot might be helpful. These green beans will have a completely different taste from fresh or canned.

Similarly, people used to dry pumpkins because most Ozark folk grew the multipurpose gourd. To dry them, cut them into rings about an inch thick, peel off the outside hull and set them on a baking rack to dry. Turn them frequently over a few days. They will rehydrate once cooked, and many old-timers swear by their flavor eaten dried. Making pumpkin butter in copper kettles was another common fall activity in the Ozarks.

Miss Jessie's Pumpkin, Squash or Carrot Butter
(one recipe, three delicious options)

Butters tend to be a bit thicker (and more buttery) than jams, jellies or preserves. They are great on toast as well as on something more substantial like a bagel or with a dessert.

6 pounds pumpkin, squash (like butternut or acorn)
or carrots (peeled and softened through cooking)
5 lemons, juice and rinds grated
2 tablespoons ground ginger
2 tablespoons cinnamon
1 teaspoon allspice
5 pounds brown sugar
1 pint water

Peel vegetables being used and cook over medium heat in pieces to soften them. Run through a grinder, including lemon peels, then add spices and sugar to mixture, as well as lemon juice. Allow to stand overnight covered. In morning, add pint of water and boil gently until clear and soft. Pour into hot, clean glass jars and seal.

Ozark folk were a bit less affected by the Great Depression of the 1920s than many others across the country. People were already living thriftily here, growing and hunting their own food off the land. A springhouse by nearby springs kept food cold as well as ensured plenty of clean, cold water, eliminating the need for refrigeration. Corn and beans could be dried by spreading across framed screens on hot metal roofs. Dried vegetables only needed rehydrating by soaking in the morning (such as with beans) and then cooking them for supper, sometimes adding pork or bacon. Apple slices were dried much like other orchard fruit. Nuts like hickory and walnut could be gathered along the roads in fall and dried to become part of the winter baking needs. When people butchered, they shared with neighbors and could even dry and can their meat or smoke it in a smokehouse to make

it last all winter. Neighbors who received fresh roasts from a deer, pig or cow would return the favor when they were ready to butcher. Home-canned meats and vegetables could appear in a potpie later. Nothing was wasted. In this way, people didn't want for fresh meat. And if they really needed protein, the woods provided squirrel, possum, rabbit and even bear, for the bravest hunters. Clear, spring-fed streams provided abundant fishing. As long as it remains the "Natural State," Arkansas should give its people all they need to eat today, as it did in the 1920s.

Irma Shore's Chow-Chow

Another way to stretch the garden came through pickling. Here's a classic pickled vegetable mix. Cauliflower or green beans can be substituted in for parts of the vegetables; just leave the green tomatoes (a chow-chow definer).

½ cup coarse salt
2 red peppers, chopped
2 green peppers, chopped
4 cups green tomatoes, chopped
1 cup celery, chopped
2 large onions, chopped
1 small head cabbage, chopped
3 cups vinegar
1 teaspoon dry mustard
2½ cups brown sugar
1 teaspoon turmeric

Sprinkle salt over all vegetables in large bowl. Let stand covered overnight. Drain thoroughly afterward. Put vegetables in a large kettle with remaining ingredients. Simmer for 20 minutes, stirring frequently. Pack in sterilized pint jars. Process in a boiling water bath for 5 minutes.

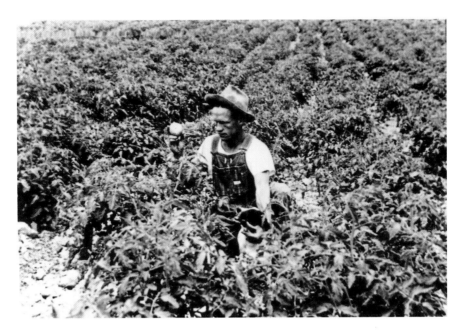

Tontitown's Italian immigrants and native Ozark folk all grew tomatoes for home use. *Rogers Historical Museum.*

For an easy, forty-eight-hour pickle, try:

Bonnie Haegele's Refrigerator Pickles

9 cucumbers (sliced into rounds)
1 onion, chopped
1 ⅓ teaspoons each, celery seed, mustard seed and turmeric
3 tablespoons salt
2 cups white vinegar
3 cups sugar

Place cucumbers packed into jars (quart or mason). Combine all other ingredients and pour over cucumbers cold (do not heat mixture). Let sit covered on counter 24 hours, then another 24 hours after in the refrigerator. They are ready to eat at this point.

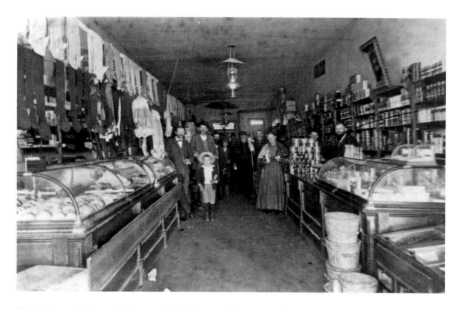

Cady General Store of Rogers held all sorts of canned and pickled items, early 1900s. *Rogers Historical Museum.*

Historically, before rubber seals and mason jar bands, people would cut rounds of paper to cover the opening on canned items, often by dipping it in brandy and placing that brandy side down on top of the glass (should it be kept from use a long time). Upon researching an old first-edition *Nyal Cookbook* from 1916, interestingly, there were no markings from its previous owner except in the canning chapter. Here, an otherwise pristine cookbook was laden with pencil markings and even missing whole recipes neatly cut out with scissors. What a poignant image—this is where the cookbook hit home for one homemaker, almost like she had just left to share the cut-out recipe of beet pickles with a neighbor. Searching in vain for jelly and jam residue in the folds of the recipes, I contented myself with highlighted recipes the past owner left behind. One such is a great "clean out the garden" pickle recipe that uses all, so nothing goes to waste at summer's end. End of the Season Pickles are one of this lady's clear favorites (keeping in mind, most any vegetable could be substituted or added).

End of the Season Pickles (from *Nyal Cookbook*, 1916)

Pickled goods make excellent ready-to-eat Christmas gifts full of color!

2 quarts green tomatoes
1 quart ripe tomatoes
3 heads celery
3 red peppers
3 green peppers
3 large onions
1 small cabbage
1 ripe cucumber
½ cup salt
3 pints vinegar (white distilled)
2 pounds brown sugar
1 teaspoon dry mustard
1 teaspoon pepper

Chop all vegetables, sprinkle with salt and let stand in covered bowl(s) overnight. Drain thoroughly next day, pressing out all liquid. Add other ingredients and cook till transparent, about one hour. Pour juice and vegetables into sanitized jars and seal in hot water bath. Store in dark place, like canned fruit. Should be ready to eat in one month or can stay in pantry up to one year.

CHAPTER 4

WILD THINGS

If a persistent traveler is willing to go up hills an' down hollers, crost branches an' through berrypatches he can still find an old man tending his bee gums, little old ladies quilting by a potbellied stove, and a lovely log cabin holding its head up proudly. Best of all he will find people so friendly and so unhurried that he will feel he has always been a part of them.
—Garden Sass

Uncultivated and gathered items are truly a cornerstone to High South cuisine, from berries and wild greens to nuts, mushrooms and honey. If the field and stream supply all one needs, the humble persimmon is a great place to start the wild adventure.

The persimmon, also known as an "Ozark date," is full of vitamins A and C and features nicely in cakes, puddings, cookies and even persimmon beer. According to student Hunter Davis, a folklore weather prognosticator lies in persimmon seeds come autumn. Just cut a native persimmon seed in half carefully, and the white embryo inside will reveal either a fork (mild winter to come), knife (cold winter cutting like a knife) or spoon shape (snow shoveling in store).

In order to cook or eat a persimmon, it is best to pick them after the first frost, when they are fully ripe on the tree; otherwise, they tend to be rich in tannins and draw much from the mouth, per gatherer Randy Brewer. The picked fruit is then run through a sieve to make a pulp. Here is one fairly simple recipe for persimmon cookies:

Persimmon Cookies

Preheat oven to 350 degrees. Mix 1 cup sugar, 1 egg, ½ cup shortening, 1 cup persimmon pulp, 1 teaspoon baking soda, ¼ teaspoon cloves, ½ teaspoon nutmeg, ½ teaspoon cinnamon, 2 scant cups flour, 1 teaspoon salt, ½ cup nuts chopped (walnuts or hickory) and ½ cup raisins. Drop on cookie sheet in spoonfuls and bake 10 minutes. Cool completely on a rack. Cookies and persimmon pulp freeze well.

Before freezers, if persimmons were not used in cooking immediately, Ozark folk would store them in two primary ways. Either they could pack whole, cleaned persimmons in brown sugar within airtight crocks or they made persimmon leather. This leather is made similarly to other fruit leathers, where the pulp is rolled out thin on a table and dried naturally. This leather could be cut into squares and used like dates or raisins. Leaves could be dried for green persimmon tea, and sap was used for earaches.

Much like the persimmon tree, early settlers also used the entire sassafras tree that existed abundantly in the Ozarks. Dried leaves from the top (smaller like a peach leaf) were ground up into the cooking spice we still use today called filé powder. Because of their delicious and mysterious smell, even trunks and limbs of the sassafras tree were used in a variety of ways, such as in the smokehouse, burned alongside hickory wood for flavor on meats. The scent kept bugs off people and out of the henhouse when used in the roosts, added a good smell to lye soap and plug tobacco (when dried together) and gave flavor to salted pork that cured in its handmade troughs. Even baked coons and possums might rest on a bed of sassafras sticks while cooking in the oven. The bark was used to make dye, mixed with roots for sassafras jelly and even steeped for sassafras tea, a favorite springtime blood thinner. According to gatherer Randy Brewer, sassafras doesn't grow tall; it's a very small tree, maybe up to six feet. It grows along roads and in wooded areas because it doesn't like full sun. Leaves turn from green to red. When you break off a branch or limb, it smells sweet like licorice. The tea, according to *The Drunken Botanist*, brewed up immediate medical benefits for early colonists. To brew it, gather and wash the roots of the red sassafras, taking only what

you need. Doing it in early spring allows the sap to still be in the root before it rises to the rest of the tree. Boil a few pieces of the root in water to make tea (letting them steep overnight if possible) and then reheat to serve hot. It can be sweetened with sugar or honey. The roots can be used multiple times before they lose their strength. Making persimmon tea is a touch simpler, as you only need the glossy green leaves, steeped in boiling water, sweetened and served hot or cold. It is very rich in vitamin C.

Like persimmons, wild strawberries are something Native Americans could live on as they traveled through Northwest Arkansas. The first settlers were such fans that the Ozarks became a land of plentiful wild and planted strawberries for some time. Picking time would be a neighborhood affair, and much like picking cotton, it was hard on the back and low to the ground. Children could help parents with the picking, as the fruit was low and lightweight. When spring strawberries came, everyone grabbed a wooden basket and headed out to the patch.

Aidan Rowe's Strawberry Shortcake

Sift together about 4 cups flour (white or whole wheat are both fine) with 3 tablespoons baking powder and ½ teaspoon salt. Add 1 cup shortening and mix until the whole mixture holds together in a ball. Roll out ball for pie crust on floured surface, baking at 450 degrees until light brown. Be sure to prick the crust before baking on a greased cookie sheet. While baking, mix about 2 pints sliced strawberries with ½ cup sugar to macerate and sweeten. When shortcake is pulled from oven, cut into squares to fit bowls serving from, layer berries in a bowl alternating with cake until bowl is filled. Top with whipped cream.

Keep in mind, if picking berries, that you aren't always alone. *Garden Sass* reveals a great tale by Mr. Farmer:

Aunt Nancy, she was gonna go down where her husband was a-workin'. And she passed a blackberry patch.... Well the blackberries were ripe so she gathered up her apron and she went to pickin' blackberries in her apron—

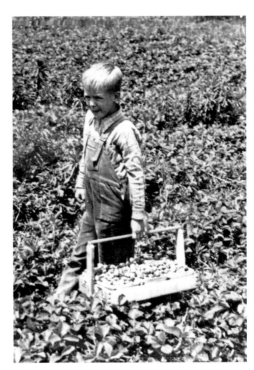

Right: Even children lent a hand picking low-level strawberries. *Rogers Historical Museum.*

Below: Many Ozark folk were needed to pick during the short strawberry season. *Rogers Historical Museum.*

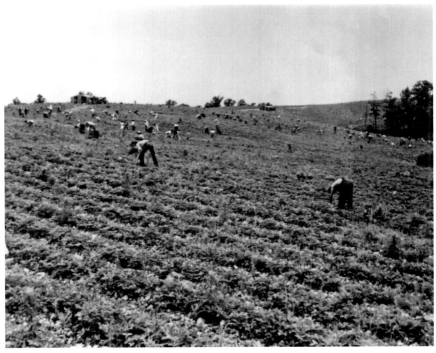

gonna make a pie. And she was a-pickin' around there and she heard a racket over close to her, and she looked over there and there was a black bear—'bout the size of a calf. And so boy she lit out. She hit the trail.

Because of Nancy dropping berries, she lured the bear to their half-finished log house. Climbing the wall, he followed behind her. "Well, the broadax was layin' there and, by George, she just grabbed up that ax and as he stuck his feet through there why she just chopped one of his feet off. Well that discouraged that bear right simple!"

Blackberry Cobbler (from David Myers, Owner, Monte Ne Inn)

For cobbler crust, mix the following four ingredients until it sticks together:
2½ pounds flour
1½ pounds shortening
1 tablespoon salt
1½ cups cold water

For the filling, mix together:
2 cups sugar
½–¾ cup flour
2 teaspoons almond extract
3 small chunks butter, dotted on top of filling
5 cups blackberries

Pour filling into pre-greased half sheet pan deep dish or large 9x13 casserole. Top with unbaked pie crust. Bake at 350 degrees until juices come up on sides, about 50 minutes. Makes 20 servings.

Huckleberries and their domesticated cousin, the blueberry, are gatherer Randy Brewer's favorite Ozark fruit. Recalling his early days working in blueberry patches, he says, "Any kind of fruit picking is always hard work, especially if you have to do it by hand."

Chantel Grant's Huckleberry Pudding

Feel free to vary the berries in this simple recipe to blueberry, blackberry or even elderberry.

1 teaspoon baking soda dissolved in 2 cups hot water
1 pint molasses
3 pints berries
flour
1 tablespoon cinnamon
1 teaspoon cloves
pinch of salt

Stir soda and water into molasses and berries, combined until very light. Add flour enough to make a very stiff batter. Then add remaining ingredients and steam for 3 hours. Serve warm with whipped cream.

More tart than a blueberry or huckleberry, the elderberry is an Ozark favorite, especially when featured in jellies or when its blossoms debut dried in a tea. Cleaned and dried elderberry blossoms can be placed in a little water and boiled for a few minutes, straining to make a fine tea. Sweetened or not, elderberry tea is great for a cold or anything else that might be ailing you. According to Brewer, elderberries are a very common berry and grow in clusters. Once their white flowers drop, the purplish-black cluster will develop, tiny like peas. Just cut the entire cluster off the shrub once they are ripe. Don't even mess with handpicking each individual berry; you will be there until next season. Elderberries can be made into a fritter, cordial or tea. Flowers can be dried for later use in infusions. Berries can also be cooked down to use in drinks, jellies, pies or even syrups for your pancakes. Whole berries can be stored in the fridge or frozen for a later date; just make sure you don't eat any of the rest of the plant (twigs, roots, unripe berries and leaves), which is toxic, as is red elderberry. Consult with a written or live field guide to ensure you pick the

right ones. The berry has a robust, fruity flavor that is fairly intense, while the flowers are reminiscent of honey. St. Germaine, the European spirit, infuses these little white elderflowers in it, which Amy Stewart likens to a "meadow in bloom; if one tries to imagine what honeybees taste when they dive between a flower's petals, this drink is surely it."

The Ozarks provide a plethora of fresh greens growing wild for the gathering.

Watercress, in the spring, grows near moving water, according to Brewer. It's a rounded leaf best picked when it's the size of baby spinach. Blooms of watercress are white or violet. With a flavor reminiscent of cilantro, it's good eaten raw with salt or with hot grease and a little vinegar. Its peppery hints lend well for a garnish. Chopped green onions and salted little radishes make a nice addition to watercress. Just eat immediately if tossed in drippings to avoid a soggy salad.

Dandelions, like watercress, are picked in early spring. They are tender until they start to bloom flowers. Pick carefully (often found in fields or grassy areas) and wash in several waters to thoroughly clean. Place greens in boiling water with a piece of salt pork to cook. Simmer one hour and drain well. Add more salted boiling water and boil another two hours. When complete, turn into colander and drain. Toss in a simple vinaigrette with chopped eggs and crisp bacon.

For lamb's-quarters, Randy Brewer instructs:

> *Gather and pick a dishpan full in the early spring when leaves are young and tender. They will be light green and velvety like a lamb's wool. Wash them well and put to a long boil in slightly salted water, including all leaves, stems and tender parts, until it cooks to fork tender. Most Ozark folk, from our earliest ancestors, have preferred a little meat fryings on them or butter, if you have it. When you get it off the skillet, it's real good together with poke sallet. Any of those raw greens, growing up I didn't eat them. As a kid, I would just walk around with a biscuit in my hand. As I got older, I started learning how to try stuff. I wasn't getting the vitamins and iron I needed. The doctors said, "If this boy doesn't start eating, he's not gonna make it." I didn't want to be a sick person my whole life. You need greens.*

Pick poke sallet when it's twelve to fifteen inches tall, at a young age. Brewer notes:

Once it ages and puts on a berry, you don't want to mess with it because the berries are poisonous. True, it's poisonous all the time, but when you cook the leaves and stems, the poison comes out. Wash it well and boil in salted water until tender, about an hour. Drain and reheat in a skillet with a little meat fryings or gravy. When it goes as berries, they go white to purple.

As a kid, Randy made the mistake of putting the berries in his mouth and got pretty sick. If you get them on your skin or clothes, they're permanently staining. "I can remember one of the neighbor kids. We'd go pick the berries and put them in a bowl. This girl next door started squeezing them out and had purple hands all summer long! It just had to wear off."

Brewer Family Pot Likker

When early settlers wanted wild greens, they'd leave them cooking in a soup kettle, served with a peppery sauce. The juice from the greens was often served separately as a dish called "pot likker." Basically, this leftover pot sauce was sopped up with cornbread and considered a full, nutritious meal.

1 cup bacon, chopped
1 smoked ham hock
1 onion, diced
2 teaspoons red chili flakes
2 teaspoons sugar
2 pounds Ozark wild greens (or kale and spinach), cut into thick ribbons
2 cups water or chicken stock
vinegar, salt and pepper (as needed)

In a sauté pan or deep iron skillet, fry up bacon until crispy, then add ham hock and onion. Sauté until onions are clear. Add chili flakes, sugar and greens. Sauté briefly, then add water or stock. Cover and cook down over low heat until greens are tender. Add more liquid as needed. Adjust seasoning to taste by adding vinegar, salt and pepper.

In addition to abundant greens, wild mushrooms tend to pop out come spring. When foraging or buying mushrooms, caps should be closed around the stems. Avoid black or brown gills. In cooking mushrooms, keep in mind they will only be good to you if you are good to them. So please don't rinse or wash them, ever, with water. They absorb liquid like a sponge. They need only be cleaned with a damp cloth or paper towel right before using them. Don't toss stems; just cut off the dry end. They spoil quickly, so try to use them within a couple days of picking or buying them. If you find you can't use all the mushrooms before they go bad, then quickly sauté them in nothing (no butter or fat) and place them in little baggies in the freezer for later. If you do get hungry, just sauté them in a little butter or oil, about two tablespoons per pound of mushrooms sliced. Then add a clove of minced garlic, some heavy cream or a shot of wine or sherry. A little fresh herb flavor, such as parsley, chives, tarragon or thyme, will be a complement. Mushrooms can also be baked whole with their stems facing up in a buttered baking dish at four hundred degrees for ten minutes. They can be stuffed and baked with goat cheese, seasoned bread crumbs or sour cream. The sky's the limit with these simple fungi, as long as they are not overcooked.

Morels are a delicious Ozark mushroom to forage. Their normal size from the ground up is between one and four inches. They look like an ice cream waffle cone turned upside down because they grow to a point. The outside of a morel is distinct from other mushrooms, carved with squiggly lines. A lot of wild mushrooms grow in the Ozarks, but please be careful not to touch poisonous ones by taking a field guide when foraging. Gatherer Randy Brewer likes to flour up morels and just fry them in a pan. "What it tastes like to me is like eating little pieces of steak. Very meaty, a great texture, not mushy. I never thought I'd eat 'em, but I can't get enough of them."

To catch their growing window, Randy notes waiting until

temperatures reach sixty-five to seventy degrees. In the spring, they come up quick, and then they're gone and just wither away. Usually in April and May, after the rains and then warming temperatures, you can usually find them in shaded, woody areas. If you ever go hunt morels, this is a good little secret: take a knife and clip it (don't pull it out), then take the morel and tap the cap gently on the ground because that mushroom has lots of little tiny seeds that you can't see, so you're essentially replanting the mushrooms and ensuring more will grow next time, by leaving the stem and scattering hundreds of little seeds from each mushroom you pick. The seeds are smaller than salt grains.

Randy has seen people try to grow morels in their yards or planter boxes but never actually achieve success. "You'll see more in the wild; just look at the north side of the hill, in a valley, where it is the shadiest. If you see white sycamores, in a grove of those, you'll usually find your morels underneath. They'll be outside of town, growing in a valley."

Although foraging nuts is possible for chinquapin and hickory, the Arkansas black walnut is the main nut in the forest. Irene Reed of Cane Hill recalls, "That was about the only kind of nut we had. Mom and Dad didn't have TV or anything, so that's what they did—crack walnuts (usually by smacking with a hammer or driving over with the car once black). You can just eat them as is—they're pretty rich. You don't need about half as much as you would in pecans." Until you need them, they store better in the freezer, especially unshelled. Toasting them brings out their flavor by baking at three hundred degrees for five to eight minutes. Here's one recipe the Cane Hill ladies all agree on, learned from their own cookbook:

Black Walnut Cake
(Adapted from *Recipes and Reminiscences of Cane Hill*)

½ cup butter (or lard with butter to equal ½ cup)
¼ cup sugar
1 cup milk
1 teaspoon vanilla
3 cups flour
¼ teaspoon salt
3 teaspoons baking powder
1 cup black walnuts, minced
3 egg whites, beaten until stiff separately

Cream butter or lard, gradually adding sugar. Then add milk and vanilla, mixing well. Then add flour, salt, baking powder and nuts. Lastly, add stiff egg whites, folding carefully into mixture. Turn out onto well-greased 8-inch round or square cake pan. Bake at 350 degrees 10 to 15 minutes until toothpick in center comes out clean.

A swarm of bees in May is worth a stack of hay
A swarm of bees in June is worth a silver spoon
And a swarm in July is worth a green fly.
—*traditional Ozark saying*

Honey was so valued in the early days that knowledge of a bee course was an object of trade. *Garden Sass* details one man remembered by his nephew to have "traded a plow head to a man for a calf and two bee courses." Once the bees were found, they could be a source of honey to people for many years. Pioneers appreciated their bees, as they used their honey to sweeten sassafras tea, make cough syrup (with a little whiskey) and make beeswax candles and balms. In the Ozarks, honey was thought to help jaundice and hepatitis when combined with the ashes of a deer horn. Even bees' stings were thought valuable to some for their anti-arthritic properties. It is now known that propolis from hives (a natural bee byproduct) is a known aid for arthritis maladies.

How does one find this treasure-trove the bees guard? All agreed that the first step in bee tracing was finding the bees, and there were several ways to accomplish this. Bees like flowers, of course, and water. In dry weather, you will find bees wherever a water source exists. A farmer could also bait them by putting out a mixture of water with sweetener or a piece of honeycomb with honey still in it. Sometimes, a hunter would spray the sweetened water all over bushes by spitting it out of his mouth, according to historian Nancy McDougal. "Then he'd wait there at the spot of the bait till a bee came and then he'd follow it back to their hive. Once a bee had 'sweetinin' it always made a perfectly direct, straight 'beeline' back to its home."

This beeline was known as a "course," so following it was called "coursing the bees." Before the bee makes its beeline, it will circle several times to reach some height before heading home. Hilariously, farmers trying to follow the circles had a hard time keeping from dizziness but would risk life and limb to stay with that bee, even in a newly cleared field full of stumps.

According to *Garden Sass*, once the hive was located, there were many ways of collecting honey or the bees or both. Hunters would rob the hive if just interested in honey. "The wiser hunters could try to create their own permanent hive by capturing the queen in their own bee box and other bees would follow her. To do this, some farmers would use bee gums (hollow sections of a gum tree, often that bees liked to settle in) and then beat a metal pan by the hive and the bees would go into his bee gum." Noise causes bees to settle, according to many hunters. Later, when men built bee boxes, they

Homer Richards, fearlessly without a net, holding up a full bee frame, 1940s. *Sheila Richards.*

still called them bee gums. If a hunter found a bee tree he could not cut at the time, he was supposed to mark it so he could find it later.

People tend to take care of needs before pleasures, of course. The pioneer was no exception. After his house was situated with all the needed structures for food and water, the Ozark man usually added some bee gums to the property. Tracing bees (to hives) became a popular sport in the early settlement days, alongside hunting and fishing. The most dedicated bee hunters would neglect other duties in the spring in order to track bees.

Bee hunting was passed on from father to son. Occasionally, someone just got lucky and came upon some bees. One such person was thirteen-year-old Homer Richards, who caught his first swarm in a flannel shirt (with the arms tied together) while walking home from school one day. Over the years, the Richards family watched their one hive expand to more than three hundred in the present day under the banner of Arkansas Honey, the oldest honey-gatherer and commercial seller of honey in the state. Homer's granddaughter Sheila Richards remembers Homer occasionally wearing a net covering his face but notes he eventually got to a place in his middle years where he no longer saw the need to wear any kind of covering when checking his hives. "He would still get stung, of course, but he took on a calm attitude when checking them or gathering honey. He would still smoke the hives if needed to calm the bees, using pine straw for the fuel." Childhood memories for Sheila include watching her grandma pull bee stingers out of her grandpa's face. He would never swell up. Not all people are allergic to bees, and it is possible that Homer's immunity to bee stings was built though exposure. If you are ever stung, do not retaliate. Just know that bees are simply trying to protect their home, queen and food source (which, ironically,

Son James W. and Homer Richards with bee boxes, 1950s. *Sheila Richards.*

Fresh Ozark blueberries. *Author's collection.*

Unfiltered Cane Hill sorghum. *Author's collection.*

Above: Chef Aidan Rowe's chocolate torte with Ozark blackberries. *Aidan Rowe.*

Left: Iron skillet frittata with Arkansas bacon and greens. *Kelsey Jennings.*

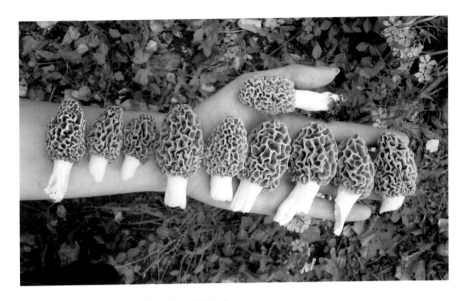

Armed with Ozark morels. *Patrick and Katie Grant.*

Oyster mushrooms in the Ozarks. *Patrick and Katie Grant.*

Ozark wild game gets elevated with fresh greens and a blackberry reduction. *Aidan Rowe.*

Lion's mane mushrooms (*Hericium erinaceous*) prepped in a Bella Vista kitchen. *Patrick and Katie Grant.*

Chef Miles James slicing a handmade cinnamon roll at his Springdale restaurant, MJ Pizzeria. *Author's collection.*

Fried chicken, okra, mac and cheese and a cornbread muffin, all from scratch, at William's Soul Food of Bentonville. *Author's collection.*

Go no further than the Wooden Spoon of Gentry for the best catfish in the Ozarks, bar none! *Author's collection.*

Bentonville food truck Priato serves up rustic pizzas with Ozark bacon jam, heirloom tomatoes and arugula. *Author's collection.*

You can't make a pie, or three hundred of them, without cracking a few eggs. *Author's collection.*

Pouring peanut butter pie properly. *Author's collection.*

Filling cream pies with nuts and coconut. *Author's collection.*

The Wooden Spoon's famous apple pie, before adding the crumb topping. *Author's collection.*

Chef Bill Lyle, of Eleven Restaurant at Crystal Bridges, crafts a beautiful hog's head cheese to further elevate High South cuisine. *Author's collection.*

Harrison-based Bansley's Berkshire Ridge pork belly finds its way to a gourmet plate at Eleven Restaurant of Bentonville. *Author's collection.*

August grapes at the Montegani vineyards of Tontitown, including Delaware, Concord, Niagara, Vidal Blanc and Cynthiana. *Author's collection.*

Ozark free-range chicken at R Family Farm, Cane Hill. *Author's collection.*

Left: Riley Remington of R Family Farm holding a favorite chicken. *Author's collection.*

Below: A flock of ducks gathered at R Family Farm. *Author's collection.*

Right: Peach cobbler cooked in a Dutch oven alongside a kettle of cowboy coffee in Cane Hill. *Author's collection.*

Below: Field corn in a lye bath on its way to becoming hominy, Cane Hill. *Author's collection.*

A Cane Hill sorghum mill that presses cane to green juice through use of horsepower, after which juice is boiled down to sorghum. *Author's collection.*

Cored, peeled and pared Goldens to feed Lincoln's Apple Festival–goers at no charge, ever! *Author's collection.*

Chicken-fried chicken plate elevates an old South favorite at Wooden Spoon of Gentry. *Author's collection.*

Ozark apple beauties. *Author's collection.*

Only the freshest regional ingredients are served on pizzas and pastas at MJ Pizzeria of Springdale. *Author's collection.*

Whipping up cream and cream cheese for Thanksgiving pies. *Author's collection.*

Arkansas White Muscadine wine chilling atop the foggy bluffs of the Buffalo National River. *Author's collection.*

Beautiful Beaver Lake presents plenty of great perch and crappie fishing in the tree sections on the shoreline. *Author's collection.*

is the very honey they produce). They are not naturally aggressive at all but just protective if they feel threatened. A good beekeeper like Homer knew and understood his bees.

Unfortunately, since the 1970s pesticides have been killing bees in addition to the bugs they're meant to eliminate. Agricultural disasters seem imminent, as crops and grazing land for cattle are not being pollinated. Beekeepers are losing their bees. It has become necessary in Arkansas to move beehives around the state in order to pollinate orchards and vegetable gardens. So if growing attractive flowers or tending bees sounds up your alley, do it! No yard or suburb, believe it or not, is too small to hold a bee box.

THE VINEYARDS

Live in each season as it passes: breathe the air, drink the drink, taste the fruit.
—*Henry David Thoreau*

According to those familiar with the wine scene in the Ozarks, Arkansas is the oldest and largest grape juice– and wine-producing state in the South. Wineries in Altus celebrate this tradition, with Post Familie Winery and Wiederkehr Wine Cellars among the top one hundred wineries in the nation for wine production annually. If you can't visit during the Weinfest of October, attend the Altus Grape Festival in July. Wiederkehr's annual Weinfest festival includes polka music, a stone toss and carriage rides through the vineyards.

According to their label, "Johan Andreas Wiederkehr brought wine-growing knowledge from Switzerland here in 1880 when he immigrated to Altus. He pioneered the grape-growing industry, planting the noblest grape varieties, producing fine wines and juices." Dennis Wiederkehr, decked in full German-Swiss traditional dress, including leather slacks with lederhosen, a hat and socks pulled up to the knee, cheerfully describes his history: "My family in the 1880s didn't bring grapes with them but grew what was here. Persimmons were doing well in the area, so persimmon wine was one of the earliest things they made." There are a lot of Italian, French, German and Swiss immigrants who all came to the Ozarks. It's amazing how well word of mouth spreads across the ocean, able to uproot people from foreign lands for the promise of a better life. They followed the railroad and new jobs, founding the community

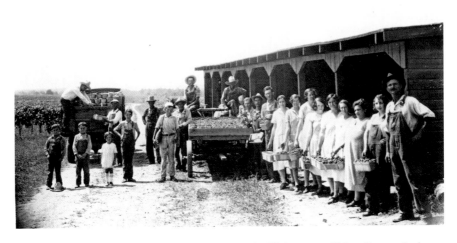

1920s grape pickers of Liv-On Farm, owned by Julius Livingston, a Tulsa oilman who later founded Forest Park, today's Lake Frances. *Siloam Springs Museum.*

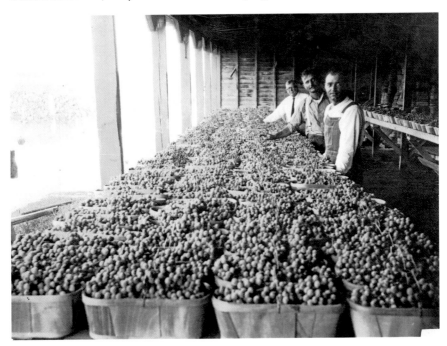

Liv-On Farm grape harvest, 1920s. *Siloam Springs Museum.*

of Altus in the hills adjacent to the Arkansas River. Winery distribution even then was pretty limited to the region, as poor transportation inhibited it. Vineyards and wineries could survive Prohibition by selling their fresh grapes as produce and wines for religious ceremonies. Wiederkehr comments that they mostly "harvest the grapes [today] with an automatic harvester similar to a combine—it beats the vines and the berries fall off. A lot of our white grapes are handpicked because they can bruise easily when machine-picked. Just like an apple that cuts, they start to brown. If our white grapes start to brown, it won't make a very nice white grape juice or wine because the color will be off and be unattractive, even if the flavor is unchanged."

The reason that you won't find the noble grapes on the vine here in Arkansas is that they don't do well in our climate. These *vitis vinifera* compose about 100 grape species, including Cabernet, Merlot and Chardonnay. But the local grapes that do well, such as Concord, can be often described as "foxy," with a strong taste, so many folks are unused to its flavors. The official state grape is Cynthiana. Should you drink a Cabernet or noble grape like a Riesling made in Arkansas, it likely will be from grape juice sent in from other places. Arkansas' humid climate and thriving pests provide a challenge to Tontitown and Altus vintners compared to the arid, maritime climate reminiscent of the Mediterranean or California. But some grapes can handle the climate and soil of Arkansas. The Muscadine, Concord and Cynthiana, as well as wild berries, all triumph.

Muscadine grapes are particularly well suited for the hot, humid Arkansas summers and terroir. They are hardy with tough skins and an extra chromosome compared to other grapes that lend themselves to survival, according to Post Familie Vineyards of Altus. They are a "superfruit," per the Posts, as Muscadines contain loads of antioxidants with anti-inflammatory properties. Muscadine skins and seeds left over from juicing are sold to pharmaceutical companies, and stems are fed to nearby cattle grazing. At this family-run operation, nothing is wasted, and nature's bountiful grape, the Arkansas Muscadine, is revered. Producing white and red Muscadine wines, as well as local Niagara, the Posts have been making wine for over one hundred years since their Swiss ancestors first settled in Altus. They distribute around the state and ensure a quality product that is truly Arkansas-made, start to finish, on their property.

Post Familie's Lee Green explains:

Winemaking is relatively simple. I don't wanna say easy, but I wanna say simple. What you do is that when you squeeze grapes, you get grape juice and,

Grape vineyard north of Gentry, Arkansas. *Rogers Historical Museum.*

in that grape juice, sugar. To make wine, you add yeast to that grape juice, and it eats up all the sugar. Yeast turns that sugar into three things: alcohol (that's the good stuff), bubbles (called CO_2) and heat. That whole process is a big fancy word called fermentation, which is really important to winemaking. Our job as winemakers is to control those elements in fermentation and to control those elements in the vineyard to get the flavors in the wine that we want.

He confirms:

It starts in the vineyard. You can't have good wine without good grapes. What makes Altus unique to wine growing? We have cool, good soil. Grapes don't like wet feet; they don't wanna be sitting in water. So our sandy, loam soil allows for drainage, but also we have some dry spells and seasons in Arkansas, so those vines can get down deep into that soil to get the water when it needs it. Also we have this thing called thermal inversion. We have the river just down the way, and warm air rises up from the river and is able to settle on our vineyards. During the spring when the grapes are really vulnerable, that warm air protects those baby grapes from dramatic bad frosts that could kill them otherwise (like an insulator). That's kind of what makes Altus unique and a good place to grow grapes.

Tourism postcard of Vinola Wine Ranch cellar, early 1900s. *Rogers Historical Museum.*

Lee notes:

> *You're not gonna see a bunch of wooden barrels. They were used two thousand years ago primarily because it's all they had to store the wine in; the flavor was just a side note. Vanilla and oak flavors will hinder the natural grape flavors. Every winery in the world uses stainless steel in some way in their winery, and most wish they could use them in all cases. Wine is just like orange juice; it can separate. We have to clarify wines and allow the gravity to pull sediment, called lees, down to the bottom of the barrel. That is why it needs time to be ready after fermentation.*

Interestingly, according to Lee:

> *Most wines do not get better with age. That is something most people don't know. Some wines do, and sometimes the cork will allow oxygen to mix with green wine and hopefully it will all age well. But most of the time, you can just seal a great fruit-forward wine like we do and go with that. If you want an aged wine, just know you're paying for each year it's been aged; and it might be fifty dollars and still have spoiled. It's like trading in futures to age wine and use corks. At Post, we just try to give a fair price upfront.*

And speaking of great deals, Lee mentions enjoying oxygen-exempt box wines, which last longer. "We even have great boxed wines here at Post."

When asked for tips on pairing wine with food, Lee was fast to offer:

Acidity in the food makes wine taste fruitier, so that's a good match, as well as salty foods with wine. People used to think it was the protein in a steak that matched so well with red wine, when really it was the salt. The salt in a steak mitigates the tannins in a red and also brings out some fruitiness and body in red wine as well. So think of protein with red wines. You want acidic wine with acidic food. There's a reason grapes grown in a region go well with other foods grown in the same soil.

With all this knowledge of wine and food, it's not surprising to note that Post really is trying "to have a pulse on the market to make wines people are wanting." Per Lee Green:

We can source the fruit; our mortgage is paid for, so we can sell it at a good price. Please understand value of a wine is never indicated by price. We have trouble selling our wines over ten dollars in some parts of Arkansas, but in Northwest Arkansas, it won't sell for under ten dollars, the same wine!

We grow, make, bottle, sell and distribute our product on the property, which is very unique for any business to do it all start to finish. The bottling room used to be the tank room, and before stainless steel we used red oak barrels. Underneath the bottling room used to be the cellars, which also doubled historically as the fall-out cellar for the town of Altus. So when people in Altus heard the sirens, they knew to head to the Post Familie Cellars; just don't forget your corkscrew!

Many members of the Post family still work inside the gift shop and cook in the restaurant, such as chef Terese Post, who loves the land as much as her grandparents. She believes in teaching her son, Oliver, how to cook and use items from the vineyard. He did reveal (at age five) that his favorite ice cream flavor is grape, so he's off to a good start. The restaurant at Post Familie Vineyards features some great German-Swiss fare, particularly the warm potato salad, featuring apple cider or wine vinegar. They keep their homemade wine vinegar only for family use, but next-door Mt. Bethel's red wine vinegar succeeds to re-create the dish's flavors. Aunt Tina Post-McCalister remarks, "We have a lot of history with food. The German

potato salad's secret is organic chicken stock, but just to finish it in the oven." The dish includes Vidalia onions, nitrite-free bacon and Post wine vinegar, as well as Bragg's organic apple cider vinegar. Tina says, "Our food is all about layering flavors; we use herbs in our onions and brats. We don't do fructose or MSG. Don't get me on the food rant; I go in the grocery store and cringe when I see what people are eating. When you look at what we eat—our society is messed up, and you wonder why we're sick. It's all curable with food—eating right, living right, getting your head right—it's all curable. People talk about farm to table like it's new. We've been doing farm to table our whole lives."

Post Familie German Potato Salad (serves 12)

15 new potatoes, cleaned and chopped, leaving peels on
1½ pounds bacon, cooked and diced (saving bacon fat)
1 onion, chopped and sautéed in bacon fat
1 stalk celery, chopped, sautéed with onion in bacon fat
½ cup flour, add to onion and celery and stir

Vinaigrette
½ cup sugar
2 teaspoons pepper
2½ cups excellent apple cider or red wine vinegar, the best you can afford
1 quart chicken broth
1 teaspoon dried mustard
½–¾ cup extra virgin olive oil, again the best you can afford as it won't be heated much
1 teaspoon dried parsley, or 2 tablespoons fresh parsley or other fresh herbs

Boil potatoes until tender, about 20 minutes. Meanwhile, make the vinaigrette by combining all ingredients in blender and then heating up vinaigrette to boiling for 1 minute. Then add hot vinaigrette to pan with bacon, onion, celery and flour mixture and cook until thickened. Season to taste to ensure it's nice and acidic yet balanced by the olive oil. Set aside. When potatoes are tender, pour into a colander, return to the pot and pour hot mixture set aside over potatoes. Toss well. Serve warm.

It wasn't just the Swiss and German immigrants who migrated to Altus; many Italian families make up the Ozark town of Tontitown. According to the book *Shadows over Sunnyside*, over four million Italians immigrated to America from the 1870s to 1920 to escape excessive taxation, poverty, food shortages and overcrowding. They desired a better life for themselves and were beckoned to a south Arkansas plantation along the delta by Austin Corbin's promises of a new life at his Sunnyside plantation. In 1895, about ninety-eight families left Genoa for Sunnyside, quickly experiencing anything but the American dream. Plantation owners didn't speak their language or provide farming opportunities like small fruit and vegetable growing that these Italians were used to, and they didn't follow through on their promises for extra work until the next cotton harvest. Poor Italian families were forced to count on company advances to buy food from the company-owned store amid an unclean water supply with malaria and disease that wiped out much of the colony. When Pietro Bandini, an Italian priest in New York City, learned of these unfair conditions and people dying at Sunnyside, he quickly rallied to move families from there to another spot where they would be better suited. He found the rural areas outside Springdale, Arkansas, safer and healthier for the Italians to raise their fruits and vegetables. His efforts led the mass exodus of Sunnyside into Middle America. In Tontitown, named for Henri de Tonti, Italian explorer and founder of Arkansas' first wilderness settlement, the peasants flourished. It wasn't easy work, mind you, but they found a way to clear the land and plant grape vineyards while they tended apple orchards and strawberry fields in the area. The men worked in the community as coal miners, railroad workers and masons. Women raised the farms and children, living that first winter on rabbit, pasta and polenta (an Italian peasant dish of cornmeal and water). Even though these immigrants lost many relatives at Sunnyside, as well as experienced prejudice firsthand on arrival to Arkansas, Bandini worked hard to help them earn respect and a place in the Arkansas countryside. Eventually, a feast developed to celebrate their establishment and new American life in Tontitown, complete with music, games and, of course, homemade Italian food. People from all over the Ozarks flocked to Tontitown to enjoy the festivities. The Tontitown Grape Festival has grown and still includes a homemade spaghetti and fried chicken dinner, as well as traditional grape stomping in wood barrels. As the 120th year of the festival approaches in 2018, the town remains a shining example of triumph, perseverance and belief in a better life that America and Arkansas could offer. For this reason, many of the original families have remained firmly rooted in Tontitown's soil, tending their now mature vineyards and raising hardworking families.

Heather Ranalli-Peachee, a daughter of one of these hardworking Tontitown families and co-owner of Tontitown Winery, tells the story of the terroir of the wine made in her town:

Grape harvest in Tontitown starts at the beginning of August. We'll harvest up until mid-October depending on weather. If we get a big rain, they crack and then the season's done. We look for the sugar content by squeezing grape juice on a refractometer, aiming for 24 percent. Then whenever you ferment, your alcohol content will end up about half of whatever the sugar content is. So if it's rained, you'll want to wait for sunny days to allow the sugar content to go back up before you pick grapes from the vine. So it's really a timing and weather issue determining when is the exact moment to pick grapes.

Additionally, beetles can be a problem for the vintner....The main issue is that we have so much humidity in Northwest Arkansas that the mold spores thrive in the ground, and when it gets hot and then rains, it splashes those spores up onto the plant. There are all kinds of still-born fungal stuff that can wipe grapes out quick. Lastly, even deer are a major pest. My dad, Chris, has gone out there many times to see two bucks with horns locked fighting between the rows for the grapes. They really eat those grapes up. So as you can see, there are many variables stacked against the grape grower.

Despite the setbacks, Heather has fond childhood memories of picking grapes in her dad's vineyard to sell to local farmers' markets and for their fruit stand, still located on Highway 412. "I've always said I think everyone needs to experience the grape vineyard in the morning; it's so peaceful."

It couldn't be a truer statement, as this author also experienced the peaceful dew of the vineyard while picking at dawn with Gil and Irv Montegani on their 1904 family homestead. These brothers remember their father selling Concord grapes to Welch's when they were children, as many Tontitown vintners did. Welch's grape products stopped buying from Tontitown in the early 1980s, unfortunately, due to the inconsistent quality of Concord sugar content the Ozarks could produce due to weather. Concord grapes like cooler summers and winters and were thus eventually chosen from states farther north. Heather remembers:

I recall Dad selling to them every year, as well as my grandpa. Tontitown grape growers were mainly selling Concord and the Niagara grape for white grape juice. Losing Welch's definitely hurt the grape production here. You would drive down old Highway 68, and there were vineyards everywhere.

Sulphur Springs' Ozark Colony postcard, 1920s. *Rogers Historical Museum.*

We had eighty acres of grapes versus our current eighteen. The fall of the wine industry happened here when the timing of California mass-produced wine combined with an expanded trucking industry made it easily available to the public. People could buy cheaper wine from farther away. People weren't as mindful then for buying local, like we are today.

Now that people care more about buying locally and fresh, Heather Ranalli-Peachee and her husband decided it was time to celebrate by opening up the Tontitown Winery, a full production winery where crushing, bottling, labeling and selling happens in less than a couple acres. Amazingly, "stomping grapes is still done. My dad still stomps grapes, in bleached, washed rubber boots, of course. We still foot-stomp seasonal fruit wines like strawberry, blueberry and peach." They do all the bottling on the premises. The only wines that are 100 percent grown in Northwest Arkansas are those made from Muscadine, Concord and Niagara grapes.

"As a true Italian community, we in Tontitown have stuck to our roots, which has really helped us," states Ranalli-Peachee. "We have maintained our identity. Here in our town, we keep it low-key; it's not a fancy dinner but a country Italian dinner and wine that's authentic. Italian families truly live in Tontitown into the fifth generation of original settlers."

Polenta

Serve underneath umedo and as a side dish with chicken or beef dishes. Whips up in a snap!

3 cups water
2 tablespoons butter
1 teaspoon beef bouillon
1 cup yellow cornmeal

In 3-quart saucepan, bring water, butter and bouillon to boiling. Reduce heat to medium and sprinkle in 1 cup cornmeal, stirring with wire whisk constantly to prevent meal from sticking to plan or clumping. Reduce heat to low and simmer uncovered for 10 minutes or until polenta is thick, stirring often.

Umedo

Heather recommends this country Italian dish of umedo and polenta, a heart-warming ragu of Tontitown cooking with tomatoes and white wine, shared by St. Joseph's Church.

2–3 pounds chicken pieces or beef round, cubed
olive oil
½ cup each, chopped onions and celery
4 cloves garlic, chopped fine
5 sage leaves, left whole
¼ cup butter
8 ounces tomato sauce
½ cup white wine
water, to cover
salt and pepper, to taste

Brown meat in oil on all sides. Pour off most of fat and sauté onions, celery, garlic and sage with butter in same pan. When vegetables are a little browned, add tomato sauce, wine and enough water to cover meat. Cook until tender on low heat; season to taste with salt and pepper. Serve atop warm polenta.

POULTRY CAPITAL

The southern kitchen…always starts from scratch,
so you can really learn a lot when you step into it.
—*Carolyn Latta*

Many Ozark folk have always kept a few chickens, mainly for eggs. When old hens were getting on and no longer laying as well as the young ones, they became a delicious chicken dinner. Chicken could be boiled, roasted, fried or canned. According to the 1904 *Gold Medal Cookbook*, "All poultry should be dressed as soon as it is killed; the feathers will come out much easier while the bird is still warm and there is no excuse for scalding." While nowadays people don't kill their own chickens, cooks of the early 1900s commonly did, even outside the state of Arkansas. Really, until chicken could be packaged and shipped, there was not much alternative for getting chicken on the table unless you butchered it yourself.

Opposite page: Dr. William Jackson inspecting baby chicks in a plane flying out of Rogers, 1946. *Rogers Historical Museum.*

Chicken Potpie (from *Gold Medal Cookbook*, 1904)

Skin & cut up the fowls into joints. Put all parts in a pot, with a little water, onion, savory herbs (like thyme and sage) and a blade of mace. Let these stew for an hour and then strain off the liquid, which will be used later for gravy in the pie. Put a layer of pulled chicken (no bones) at the bottom of a greased pie dish, then a layer of chopped ham, then one of forcemeat (small pieces of meat) and hard boiled eggs, cut into rings. Between the layers put a seasoning of mace, nutmeg, salt and pepper, all to taste. Pour in about half a pint of water. Use a pie crust (top crust only) to go over the dish and adhere to sides of pie pan. Glaze with an egg yolk. Bake at 400 degrees for an hour and a half. When done, pull from oven and pour in awaiting gravy by making a small hole in top of pie.

Chicken soup is about as proverbial as a medicine cabinet full of aspirin for curing heartache, a cold or a down-and-out kid who got picked last at dodgeball. It's comfort food to all, especially us Ozark folk. It's also a great way to eliminate a noisy, aggressive rooster. Because this is a recipe that calls for parboiling and then simmering, an older or tougher fowl like Mr. Cocklespurs can be used. You'll still have something to crow about at the end, even if he doesn't!

Chicken Soup

Don't worry about which parts to use. Wings, gizzards, even feet make excellent soup. You can remove the parts at the end if the sight frightens you, just as long as their flavor has been extracted. If you have stock as your starting base that will really improve it, but if not, just get your chicken and parts parboiling in salted water to cover and pull it out when falling off the bones. Skim the fat off the top as it cooks. While pulled chicken is cooling on a cutting board, add in vegetables: 1 cup each diced or sliced carrots, celery, onions, even parsnips and 1 to 2 bay leaves. Add more water, if needed, to broth and cook vegetables for 45 minutes. Always add 1 to 2 tablespoons acid in this soup, or any for that matter, to finish and balance. For this soup, add lemon juice and finish with a tablespoon of fresh minced parsley, then season to taste. If you do add noodles, pre-cooked rice or dumplings, just keep in mind they will absorb liquid, so plan to adjust.

If you're looking for a good dumpling recipe, whether cooking chicken, squirrel or beef soup, just drop these little beauties right in the pot. We Ozark folk have been cooking dumplings since our early ancestors, and there's no need to stop now. They're good and fairly easy; just add them to the pot with meat and liquid. Cover the pot for twenty minutes. And, like Christmas, don't peek to get the best gift: fluffy dumplings!

Gail Brewer's Dumplings

Sift together 1 quart flour, 2 tablespoons baking powder and a pinch of salt. Blend in 2 tablespoons butter then 1 beaten egg and enough milk to make a fairly stiff dough. Roll on floured surface, cut into small 2-inch squares and drop into boiling broth (of item being cooked) and simmer with dumplings 20 minutes covered then 10 minutes uncovered.

Many people will tell you that fried chicken or other southern foods are impossible without an iron skillet. They are probably right. Most of that flavor from a well-seasoned skillet cooks into the food. That's why you never scrub your skillet and always keep a nice, shiny black sheen on it with oil so it won't rust out. A must-have tool in the Ozark kitchen, they can even be taken out to the campsite, backyard barbecue grill or fire pit. Skillets can handle the heat of coals, so next time, take one outdoors to try out a recipe.

Fried chicken is the showpiece of this 1942 family picnic. *Rogers Historical Museum.*

Cooking and eating alfresco isn't something new. Historically, women brought room-temperature fried chicken to after-church picnics and socials in the Ozarks. Let it cool on the same day it's cooked for the best results. What's good hot, cold or two days old? Fried chicken!

Helen Brewer's Fried Chicken

Cut up whole chicken into 8 parts, salt and pepper thoroughly, then flour pieces on a plate or shake in a paper bag. Toss bag. Heat up 1½ cups melted lard or shortening in an iron skillet of ¾ inch depth over medium-high. Sear and fry floured pieces of chicken without overcrowding skillet, usually 10 to 12 minutes per piece. Drain chicken of oil on prepared rack set over a baking sheet to catch grease. Keep warm in 300-degree oven or allow to cool to room temperature to serve.

Batter Fried Chicken

Homemaker Bonnie Haegele's variation uses marinating and a batter.

With fried chicken you brown it first, then you put your lid on it. Before serving, take the lid off, and they'll crisp back up. I use flour and egg batter with milk, and sometimes a cracker crust mixed with flour. Potato chips or cornflakes can also be used in the batter. Just get your crumbs very fine. If you want your chicken tender, marinate it in baking soda and water for about half an hour. Then wash it off. Since the kids left, I just don't cook as much, so my fried chicken isn't as good as it used to be.

So where do you head in the Ozarks for great fried chicken that's not at grandma's? Look no further than the Ozark institution of Monte Ne Inn for family-style chicken dinners complete with all the fixings of a Sunday meal, including green beans, fresh corn, mashed potatoes with gravy and bean soup. Top all that off with apple butter on fresh bread and the best darned fried chicken around. David Myers, host and owner, is extremely accommodating, albeit reserved with his secret recipes, which are staying in the kitchen. He generously passed on his blackberry cobbler recipe (found in chapter 3). Frying chicken is a culinary science in the Ozarks, so if Monte Ne Inn has been serving the same menu since 1970, they must have figured it out. That's all you get at this iconic institution: a chicken dinner amid farm equipment–lined walls in a packed dining room. It's a little out of the way, too, in historic Monte Ne on Beaver Lake, indicating locals and visitors find it worthwhile to flock to a place serving up a good flock of chicken.

Chicken by the hundreds inside a broiler house. *Rogers Historical Museum.*

Myers states:

Advertising after forty-four years is largely word of mouth, which seems to work well. Everything is made from scratch except the apple butter. There's no way to keep up with that demand. We only buy from one chicken supplier. I'm using Cook's out of Texas because I use a 2.5-pound bird. I would have to gut the kitchen and add more fryers to accommodate a bigger bird, which someday I may have to do, because it's getting harder and harder to find a smaller bird. I get it; they make more money off of a bigger bird. For me, I like a smaller bird because they're tenderer and have less sodium and more flavor. It's all you can eat here, so you have to pick at it more, but people still seem to like the smaller chicken. People tell me that it tastes the same as it did twenty-five years ago. Our goal is to be simple and consistent; that's what's always worked for us!...We're more about friends and family coming to the table than any other thing. That's why there's no music playing, no TVs in the restaurant and we're only open for three hours. We want you to be happy, we want you to eat and then we want you to go home to spend time with family.

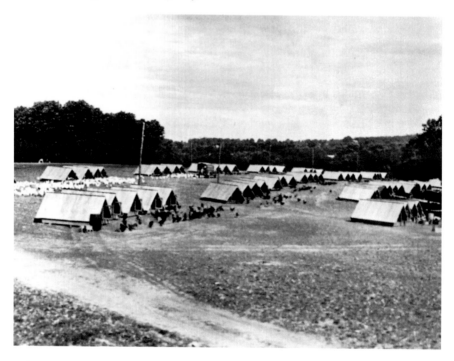

A-frame architecture for chicken houses of the early Ozarks. *Rogers Historical Museum.*

A two-story chicken house in the Ozarks, mid-1900s. *Rogers Historical Museum.*

Myers is also correct on Northwest Arkansas' place as the chicken capital of the country. It wasn't always that way, but people in the 1900s found they couldn't raise cotton in the poor Ozark soil like elsewhere in the state, giving rise to heavy chicken farming and broiler houses dotting the farms of Northwest Arkansas. These farms grew into enterprises in the mid-1900s. One such giant, Simmons Foods, ranks among the nation's twenty largest poultry producers. The *Herald Leader* acknowledges the company was very innovative, even in its infancy. Simmons's 1950s' inventions of chicken hot dogs, canned whole chicken and chicken rolls were years ahead of their time. Its founder, Bill Simmons, invented hydrolyzing feathers, chicken heads and wings into livestock feed because there was "too much to feed the hogs and too much to let gather on the ground." As he often said, "We use everything but the squawk."

Vitally central to Northwest Arkansas' chicken impact is its world headquarters of Tyson Foods, Inc., one of our nation's top three poultry, beef and pork producers. It's not just chicken at Tyson, but that's how the late Don Tyson began. Per the *Rogers Morning News,* "Tyson was one of three in his generation—including Sam Walton and J.B. Hunt—whose bold vision, quick thinking and single-minded determination changed the Ozarks with true transformative power."

GAME AND FISH

Deep in the forest and waters, you'll find the savior of Ozark cuisine: our wildlife. Hunters in territorial Arkansas had to hunt to survive; there was no other alternative. Hunts were remarkable proofs of bravery, as men would spend days traveling to pursue dangerous bears and deer for their hides, a form of currency in the state, and for their meat, a staple of the frontier diet. Hunting animals was just a way of life for Ozark folk. Folklore and tall tales (how big was your fish?) of course evolved with the hunting.

Henry Rowe Schoolcraft, as a geologist and explorer, did much for telling tales of the Ozarks in the early 1800s. He came to the Ozarks when the first of the early pioneers were making their homes in its hills. Beginning in 1818, he recorded observations on the water, the soil and the ways of life among Indians and early settlers here, according to his journals. One such record remarks:

These people subsist partly by agriculture and partly by hunting. To excel in the chase produces fame, and a man's reputation is measured by his skill as a marksman, his agility and strength, his boldness and dexterity in killing game and his patient endurance and contempt of the hardships of the hunter's life. Meals are at daybreak and then at 5pm with nothing for mid-day. It consists of bear-bacon, hominy (corn boiled till soft) and sassafras tea, with no variety. They sleep on bearskin by the fire and repeat the day's meals and work till the hunters return many days later. They are, consequently, a hardy, brave, independent people, rude in

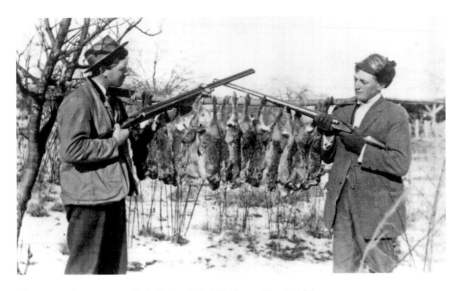

Two young hunters proud of their rabbit kill. *Rogers Historical Museum.*

appearance, frank and generous, travel without baggage, and can subsist anywhere in the woods.

As Schoolcraft began his journey, he admitted to a lack of preparation and knowledge in the way of dress and hunting, as well as how to cook venison or even boil coffee. This was acknowledged by the first settler they met, a woman knowledgeable of the Osage country as well as living in the Ozarks. Schoolcraft, on the other hand, was so inexperienced with the outdoors he managed to kill his own horse and almost himself, per historian Brooks Blevins. Schoolcraft was unprepared for the Ozark wilderness, having a gun that, as one settler's wife acknowledged, would not handle shooting game or even protect them in the woods. During their travels, Schoolcraft and his assistant found themselves awaiting their guide, a hunter, within the walls of a saltpetre cave. He remarked how it was hard to find happiness but in wealth, power and prominence. Very sad. Here Schoolcraft was in a beautiful natural cave on a lovely Ozark river dreaming of things unnatural with a wealth of beauty surrounding him.

Most people wouldn't dream of entering a state with so much wildlife without knowing how to hunt. Arkansas was once known as the "Bear State," an indication of the abundance of this mammal, per *The Ozarks: Land & Life.* Bear meat was dried and barbecued or else smoked much like hogs. It is no surprise that people hunted bears, as they provided substantial meat and

A female hunter on the Ozark bluffs along the White River. *Rogers Historical Museum.*

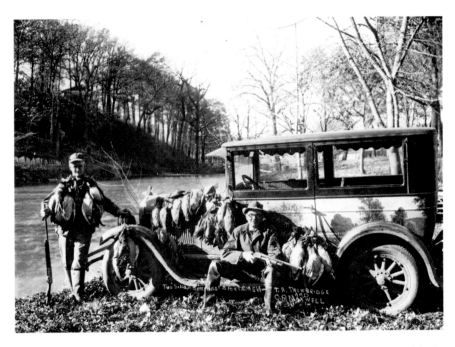

Two Siloam Springs sportsmen, T.A. Trowbridge and O.P. Maxwell, display a flock of fresh-killed ducks. *Siloam Springs Museum.*

Four men working a turkey farm. *Rogers Historical Museum.*

cooking grease. One White River town in Arkansas was named Oil Trough for the large hollow log troughs of bear grease (oil) that it shipped elsewhere in the United States in the 1800s.

According to Jeff Wartchow (former hunting and fishing resort owner), "Ground bear meat can be mixed with ground beef to make burgers. Bear roasts are also nice cooked in a Dutch oven, seasoned, covered with cream of mushroom soup and cooked over low for a long time, later adding potatoes and carrots. For bear chili, it's good to cube the meat and cook it low and long."

Bears weren't the only game in Arkansas being hunted, of course. Wild duck and turkey would still make an occasional appearance on the settler's table. Here's a great recipe from Gail Brewer that works for both fowl:

Wild Duck (for two ducks or one turkey)

Clean, pluck and season ducks inside and out with salt and pepper. Combine stuffing ingredients and stuff ducks, placing both together snugly in roasting pan. Place any extra apples or raisins around them that you don't use in stuffing. Place 2 bacon strips over each duck (they dry out easily). Pour about 1½ cups water into pan. Bake at 350 degrees until tender (about 15 minutes per pound). Add more water if necessary.

Apple Stuffing for 2 Ducks
(if 1 duck, just cut recipe in half)
6 cups stale bread crumbs or cubes
2 Jonathan apples, unpeeled and diced
2 small onions, diced
6 tablespoons melted butter
2 teaspoons salt
1 cup raisins
water to moisten all ingredients once combined

Even more important than any of these meats, pork fell into very high esteem due to its abundance in the Ozarks. When a pioneer moved to an area, according to *Garden Sass*, he'd usually be asked by the original settler in that part of the Ozarks if he wanted to buy a hog claim:

For two dollars you could buy into this hog claim bunch there, and that gave you the right to the meat whenever they had a hog killing...When it got winter and bad weather and the hogs couldn't get as much as they needed, a feller on a mule would take some corn over to the spring and strew it around....In this way, they'd bait the hogs in an area where it'd be easy to scald and dress the hog once killed....Then the meat would be dressed and divided up among those present that had bought a hog claim.

Hogs were slaughtered on cold days by a community of people because it was a lot of work, and not a pleasant gathering, but a necessary one. "I liked the hog killing time," remembers Cane Hill resident Betty Colburn. "We always had liver on Thanksgiving day because that'd be the day we killed pigs. We had a lot of folks around to help. The neighbors came in and helped each other, and they'd kill more than one hog at one time. The women and men, too, both came, and they made a day of it. Everything was greasy; a very messy time." Her friend Margaret Lofton agrees: "Whenever a hog was killed, they'd make sausage patties, put them in a quart jar and pour their own hot grease over them to seal it."

Chef Bill Lyle's Souse

At Crystal Bridges' Eleven Restaurant, you'll find one chef who likes to challenge himself with fusions of Ozark ingredients like pork, even if they don't always turn up on the menu.

I pig's head
4 hooves
I cup white wine
I tablespoon black peppercorns
4 tablespoons salt
6 garlic cloves
I cup chopped parsley

Combine all ingredients except parsley in a pot. Add water until about I to 2 inches above skull. Simmer on low for 4 hours. Remove bones and pick meat. Reserve and refrigerate meat. Add bones back into water. Simmer 2 to 3 hours longer. Remove bones, checking thickness of gel. Reduce liquid by ¼ if needed. Strain broth into mold and stir in with meat and parsley. Refrigerate and slice when congealed. Serve with other charcuterie items like mustard, jam and pickles.

Early settlers understood the value of the smokehouse, quickly building it after water was sourced, per Nancy McDougal. Food preservation was a top priority, using the smokehouse to store and preserve wild game, especially the abundant hog. Hogs often ran free on the range, earmarked by the owners, coming to be known as "razorbacks" with reputations of being as mean as a mama bear with her cubs. Stock laws eventually came into place, but both wild and tame hogs continued to be killed in the same way—in the winter, with most of the meat preserved in a smokehouse. The bony parts, like ribs, were immediately eaten since they easily spoiled. Then hams, shoulders and bacon parts were hung in the smokehouse.

Jeff Wartchow's Roast Pork Spareribs

Dredge with salt, pepper and flour, setting all ribs to cook in a roasting pan at 375 degrees. A good rule is cooking 20 minutes per pound of pork. Baste every 15 minutes with meat drippings in the pan. Serve with apple sauce once meat is thoroughly cooked, no pink.

What early Ozark folk loved hasn't changed much. According to Hunter Davis, more than 1.8 million pigs are produced in Arkansas annually. Each American, on average, eats around eighteen pounds of bacon per year. He declares, "It could be one of our leading causes of cancer, but bacon is still an integral part of High South cuisine. That all connects; so really, is it worth it to have cancer or is it worth it to have bacon?"

An important ingredient in Ozark cooking that doesn't always receive the limelight is fatback. This is aptly named, as it is the clear fat taken from the back of a pork loin. It can be salted or smoked and appears often in recipes once it's rendered into lard. Lard was oil for Ozark settlers' cooking. Its fried counterpart became cracklins, a favorite ingredient in cornbread. Another often overlooked part that Crystal Bridges' Eleven Restaurant doesn't ignore but elevates to a gourmet experience is pork belly.

Hogs on a family farm were a blessing for the large amount of meat they'd supply all winter long. *Gail Brewer*.

Chef Bill Lyle's Pork Belly (Eleven Restaurant)

Do a nice braise with your mirepoix (celery, onion, carrots—fine dice), and I use red wine, red wine vinegar and stock. Braise it down. Cool it down, cut it up and sear each piece on all sides. Serve with black cherry gastrique.

Black Cherry Gastrique
6 cups sugar
1 ½ cups water
6 cups red wine vinegar
¾ cup dry red wine
8 cups frozen cherries

Combine sugar and water. Boil without stirring until light blond in color. Add red wine vinegar and whisk until crystals dissolve; reduce until syrupy. Add wine and cherries, break down berries and simmer 8 to 10 minutes. Strain through chinois.

Even the way Ozark folk played and celebrated had food mixed in as part of their folklore. One square dancing song mentions needing to hold a man's mule while he runs out to catch a possum. Names of specific square dance moves like Chase the Goose, Break the Chicken's Neck, Shuck the Corn and Dig for the Oyster all had links to what people ate. According to George House, "We'd trap raccoon, possum and skunk in the late '40s and '50s, then sell the hides at the general store (about one dollar per hide) but they started to kick us out when we brought the skunk hides!"

One folklore song, according to Ozark musician Danny Eakin, rings out:

> *Bye-bye to that possum.*
> *Fire that possum down.*
> *Bye-bye to that possum, when the possum hits the ground.*
> *Oh, we'll have a big dinner when the possum hits the ground!*

The song goes on to talk about "sugaring him up" and placing the possum in a frying pan with sweet taters all around and gravy made from the drippings in the pan. Now this might sound a bit unusual, but its place as a folk song indicates its relevance in Ozark culture.

Coon hides to sell, with meat ending up in a family dish like coon and sweet potatoes. *Gail Brewer.*

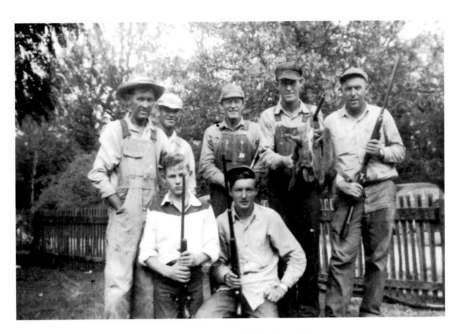

George House and family after a squirrel hunt, 1950s. *George House.*

More than any other meat, squirrel awakens distinct memories for Ozark folk. Hunter Davis shares, "The Ozarks are known for hunting, like venison and all that goes with that. My grandmother every morning would take whatever animal brains she had in her kitchen and scramble them with eggs. Squirrel, possum and deer…whatever she had on hand to cook for a crowd." Margaret Lofton cringes: "My husband just couldn't go it when people ate squirrel and eggs." "I remember Grandpa hammering the squirrel brains and getting the brains out of the squirrel," recalls Wanda Biggs. Cane Hill resident David Latta tells, "When we first got married, we didn't have much money saved up yet. All the squirrels were getting the message to watch out for David Latta…run!" Some Arkansas hunters, like George House's father, were so avid that George recalls seeing fingerprints worn into his single-barreled shotgun. Not surprisingly, "I was shootin' a 22 by the time I was six years old," states George, "and I'd go hunting by myself at twelve."

Perhaps the Ozark folk learned from the Cherokee, who also ate squirrel baked over an open fire. Here is their preparation method.

Sa-Lo-Li, "Baked Squirrel" (from *Indian Cookin'*)

Dress freshly killed squirrel first by singeing off animal's hairs using leaves on a twig (or today a rolled newspaper) outside. Wash and scrub off hair using the ashes of the fire. Wash again and when thoroughly scraped, cleaned and with the innards removed, rub squirrel with lard, inside and out. The Indians would rub the animal with wood ashes until it was white before baking in an open fire (or you could place in the oven), cooking till brown. Indians would stew or fry the squirrel, using the drippings to make a gravy with home-ground cornmeal as the thickener, versus flour.

Hungry for squirrel and dumplings or potpie? These can be made by using the recipes for chicken and dumplings or chicken potpie in the poultry chapter, noting that one chicken is equal to three squirrels in meat quantity when substituting. Rabbit can also be used interchangeably anytime squirrel is in a recipe.

Local Ozark native and game lover Joe Wilson founded the squirrel cook-off that became Bentonville's World Championship version when Andrew Zimmern covered it in his 2012 *Bizarre Foods America* segment. It's a great boon for Arkansas, where fantastic art galleries and urban living might keep visitors from uncovering Ozark roots. "The World Champion Squirrel Cook-Off is here to bring back all that is good about eating squirrel and other wild game meats. Hunters and fishermen are actually our nation's conservation enthusiasts. They create hunting limits because they care and love the land, animals and all they give back." Contestants are required to provide their own meat, with many hunting it. The squirrel per team must begin as recognizably squirrel, so no prepping is permitted besides dressing it. Teams have an intense two hours to prepare and serve their dishes to about ten judges, with each dish required to contain at least 80 percent squirrel, with bonus points given to side dishes with squirrel. Food is judged on taste, appearance and unique use of squirrel. Even booths are judged for showmanship, which can include costumes, booth décor and cooks' demeanor.

This author tried her first squirrel at the festival, including squirrel gumbo, squirrel paella and even squirrel bacon. Notes of fried squirrel, of course, were continually wafting through the air of downtown Bentonville's side streets as

people jubilantly cooked what Granny used to make in the Ozark kitchens of time gone by. It's events like these that keep alive Ozark heritage, telling food stories to the world that thinks we're maybe a little unusual.

2014 World Championship Squirrel Cook-Off Winning Dish: Squirrel Meatloaf

Contributed by Champions Dorothy Hall and Casey Letellier

3 grey squirrels and 2 fox squirrels (or 26 ounces equivalent in trimmed squirrel meat)
6 ounces bacon
2 tablespoons bacon fat or butter
½ cup yellow onions, minced
½ cup local apples, peeled and minced
salt and pepper to taste
1 tablespoon fresh sage, minced
1 large egg
½ cup cornbread crumbs

Grind squirrel and bacon together. Meanwhile, heat bacon fat in a skillet and add the onion and apple with a generous pinch of salt and pepper. Sauté until onions are starting to soften and turn translucent. Add the sage and stir to combine. Remove from heat. In a mixing bowl, combine the ground squirrel and bacon, apple mixture, egg and cornbread crumbs. Using your hands, knead together until well combined.

In a smoker: Shape meatloaf and place on a perforated pan. Smoke for 1 to 3 hours, preferably with hickory, keeping the temperature between 225 and 275 degrees. Meatloaf is done when instant-read thermometer inserted into middle reads 155 degrees.

In an oven: Shape meatloaf and place in a bread pan. Bake at 350 degrees for 1 hour or until instant-read thermometer inserted into middle reads 155 degrees.

Serve with ketchup and pickles and an Ozark Old Fashioned.

Ozark Old-Fashioned

½ ounce sorghum (adjust as needed for sweetness)
2 dashes black walnut bitters
2- to 3-inch-long orange peel, thinly sliced with as little pith as possible
2 ounces corn bonded whiskey
5 pecans, toasted

Muddle sorghum, bitters and orange peel. Add the biggest ice cube(s) you can find and whiskey. Stir briefly and garnish with a couple of pecans you've toasted in a skillet until they smell delicious.

Indian wedding ceremonies included food as a major part of their unspoken vows to feed each other, as the man exchanges a leg of venison in a Cherokee ceremony with his wife, who then exchanges an ear of corn. Each symbolizes their ability to provide meat freshly hunted by the man and bread made by the woman. This is part of their promise in marriage, according to the book *Indian Cookin'*.

Venison Sausage

This venison recipe uses a large quantity of meat from freshly hunted deer.

19 pounds ground venison meat
6 pounds fat pork, ground
1 cup salt
4 tablespoons ground sage
3 tablespoons ground pepper
2 tablespoons brown sugar
2 teaspoons apple pie spice
2 teaspoons cayenne
2 cups flour

Mix all together well. Store in freezer in serving-size packages in rolls. Adding a little sausage to the mixture will help them stay together when they are fried.

Trout is plentiful in the Ozark lakes and rivers of Northwest Arkansas, particularly spring-fed White River, regionally famous among fishermen for rainbow and brown trout. Native Americans in the Ozarks hunted and fished this land before the early settlers discovered the river. According to Kenneth L. Kieser, the White River,

> *the narrow chute of chilly water from the depths of Bull Shoals Lake was once a meandering warm-water stretch that moved flat boats of settlers and their possessions to a hard, often challenging life of settling in Arkansas' Ozark Hills. Settlers could transport log homes and later learn to fish the abundant waters of the White. Later in the 1920s, people made $2–10 guiding wooden johnboats down the river as fishing guides for the tourists that arrived by train and road. They craved the Ozark simple life and also the knowledge of the best goggle eye, perch and bass holes. In 1941, congress approved construction of the Bull Shoals Dam, but WWII delayed the $106 million project that eventually made the chutes released too cold for most species, except trout. Perfect conditions for German brown and rainbow exist today on what's left of the White due to the damming process, as well as along later-formed Beaver Lake that allows for some great fishing and guiding currently, but for a bit more than $10 a day!*

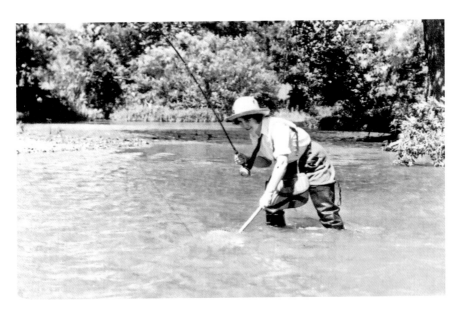

River fishing in waders is the best way to catch Ozark trout. *Rogers Historical Museum.*

Postcard advertising fishermen's camp on the White River, near Monte Ne, early 1900s.
Rogers Historical Museum.

Blake Clardy's Smoked Trout

Take a whole trout, cleaned and dressed, and cram inside rosemary, thyme, a couple lemon slices, salt and pepper. Seal open trout together with cooking twine. Smoke 30 minutes or less over alder chips at 250 degrees.

Bacon-Grilled Trout

A versatile recipe and technique that can be used on other small fish, like bass or perch.

4 whole trout (9–12 ounces each); ensure they are filleted and butterflied for better cooking experience
1 tablespoon salted butter, room temperature
coarse salt and pepper
4 whole scallions, trimmed on ends
8 slices bacon
2 lemons, cut into 4 rings each

Preheat grill on high and oil the grate. Prep trout by smearing butter on each fish, inside and out. Season generously with salt and pepper. Place a scallion in cavity of each fish. Place 1 slice of bacon lengthwise on each side of fish (2 bacon per fish). Secure with butcher's twine. Place fish on grill, then immediately reduce heat to medium-high, grilling with lid open until brown and cooked through, 6 to 8 minutes per side. Snip off string, place two rings of lemon on top of each trout and serve.

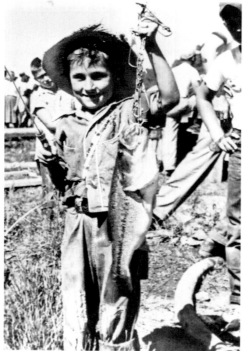

Above: One half-day's catch caught on the beautiful Illinois River that runs through Forest Park, caught by Leon Brown, Bob Ewing and John Stockton, November 29, 1926. *Siloam Springs Museum.*

Left: A happy fisherman on Kid's Day in Rogers. *Rogers Historical Museum.*

An Ozark postcard lauding the fine fishing of Rogers, Arkansas. *Rogers Historical Museum.*

Ozarker Randy Brewer was fishing as soon as he could walk.

If I had a plate of crappie and a big steak, I'd pick the fish every time. But if you wanna eat fish, you have to know how to clean. I don't scale them; it's messy. I had a good teacher that taught me how to fillet it out, which removes the skin with the scales if you do it right. Skin left on a fish creates that fishy taste. For my favorite fish, crappie, you'll need to go early morning to late afternoon. The brim or perch are easier to catch than crappie because crappie are finicky (they like to hide by trees, docks, brush and shade). They like their safe zone. Bass and catfish like different levels of the water.

Randy's Fried Catfish

This recipe can also be used interchangeably with perch or crappie.

Salt catfish fillets and roll in yellow cornmeal. Heat 1½ inches of canola or peanut oil to medium heat in large skillet. Fry about 3 to 4 minutes each side or until golden brown. Do not crowd the pan. Lay fried fish on paper towel and serve hot (if doing a big batch, hold in a 300-degree oven until all of batch is completed).

APPLES

\mathcal{A}pples were of crucial importance to Northwest Arkansas from the late 1800s into the 1920s. Sprawling orchards had large crews to pick apples with tailor-made crates and ladders. Ozark apples were processed in a couple of ways. Vent stacks were used, where a box of sulfur helped bleach apples to be dried. Machines, often operated by women, peeled and cored apples. A cider press crushed the bruised, rejected apples and skins into mash for cider making. Many towns, like Siloam Springs, housed evaporators to dry apples, distilleries to make cider and vinegar and ice plants to cool apples shipped whole for eating. "Ads read, 'I need 1,500 workers for my orchards, farms, etc.' A quarter of a million fruit trees were sold annually in many Ozark nurseries in the 1900s. It's staggering how much impact it held on our economy," states historian Rick Parker.

The Ozark town of Lincoln was "once the apple capital of Arkansas," according to longtime resident Doug Hulse.

The railroad ran through here from Fayetteville to Muskogee, and they used to ship them out in barrels to get onto the rail cars. (The rail tracks are very close to the Lincoln square.) People did a lot of Jonathan apples here. They also grew Arkansas Black apples. They're not a very good eating apple, but they were solid and shipped nice. There also used to be a lot of apple dryers in the area. When the Lincoln Apple Festival first started, Apple Town out in Lincoln had three hundred acres, and they sold apples to make cider. People used to judge the apples and give prizes, and the winner might get $500 for a bushel of apples. Now there aren't any apples to judge.

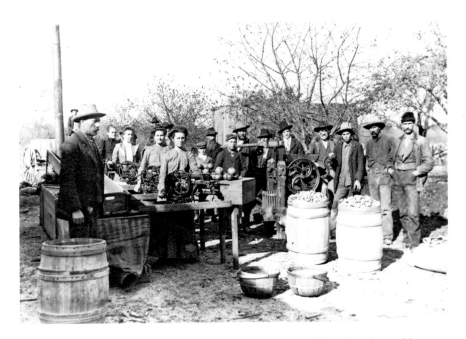

Apple processing at A.E. Rausher's orchards near Fairmount, 1900. *Siloam Springs Museum.*

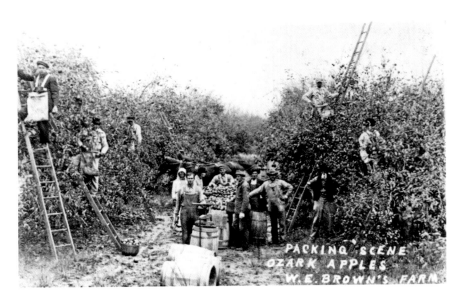

Packing scene of Ozark apples at W.E. Brown's farm, Rogers. *Rogers Historical Museum.*

It's shockingly true. Cidery owner Leo Orpin explains:

> *Northwest Arkansas in general has a rich, rich history and was known as the apple belt of the United States because it had the most apples grown anywhere at the time, in the early 1900s. But nobody knew what they were doing. It was more like the folks in the Ozarks had a lot of land and just picked up a hot cash crop. So everyone started growing apples, and they all died of diseases, and then the Great Depression came.*

During this time, those just struggling to feed an Ozark family didn't have coveted apples on hand, ironically, in an area that twenty years before had been the nation's apple belt. One gentleman, George House, still remembers the rare joy of getting an orange and apple for Christmas in a brown paper sack during this time in Arkansas.

Despite their rough past, the good folks of Lincoln still annually celebrate the apple's former prominence through an annual festival, even though no active apple orchards exist in the town at present. They have been hosting the Lincoln Apple Festival since 1976, according to Mayor Rob Hulse. The festival includes a talent contest, antique tractor parade and complimentary fresh sliced apples to all attending. Volunteer-made apple dumplings, cider, Ozark beans, cornbread and apple butter all are available for a nominal price to help support the town. Live dulcimer, gospel and bluegrass music in the Ozark tradition entertain festival goers, as does an apple-throwing contest. "We look forward to this every year and don't ever get tired of apples," states Ozark resident Bobby McDonald.

Historically, the oldest apple orchards were seedling orchards, meaning that each tree was started from seed, resulting in a hodge-podge of novel and unusual apples. Thus, "early ciders would have been a blend of the fruit in the orchards that just weren't sweet enough to make the cut for eating apples," according to botanist Amy Stewart. "When certain ciders were popular or apples of a certain cultivar, the only other way to reproduce an exact preferred cultivar was to graft it onto the rootstock of another tree, a technique that's been around since 50 BC." Apple farmers could clone fruit this way, and the popular varieties that came about from grafting eventually acquired their own names. "During the early frontier days, John Chapman (aka Johnny Appleseed) was doing all he could to keep it natural in America, establishing apple nurseries on the frontier's edge in the early 1800s. Grafting apple trees was a wicked, unnatural practice in his book. He advocated all apples to be grown from seed, just like nature intended." Thus, early settlers

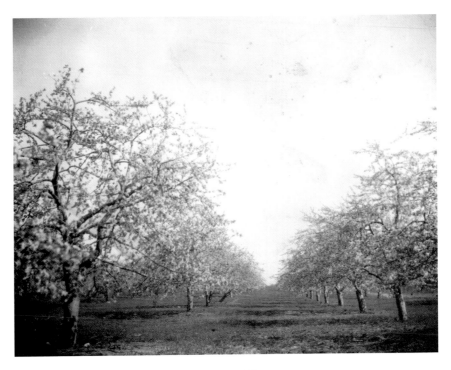

Apple orchard near Siloam Springs. *Siloam Springs Museum.*

and Ozark folk made cider only from uniquely American apples, not from well-established cultivars of Europe.

Without the right equipment, beer was difficult to make during this time. Cider, however, was fairly simple, consisting of just apple juice and yeast, according to cidery owner Leo Orpin. Even good ole' Johnny Appleseed was behind this idea, with his plantings yielding "spitters" meant for cider, not eating. The unfermented juice of apples was frequently called sweet cider (not to be confused with the fermented, harder sort). It is one of the favorite drinks of Ozark history, and just about anyone with access to a press could make their own. Winesap apples were popular for making cider. Specifically, apples that weren't for eating or were bruised could still become heroes in a nice batch of cider. Making the cider from late apples because of a higher fruit-sugar content, cider would stay sweet for days if refrigerated or for several months if heated to a high temperature and bottled. Apples were crushed first and then pressured in a cider press, which were quite common in the big apple-growing region of Northwest Arkansas in the late 1800s to 1900s.

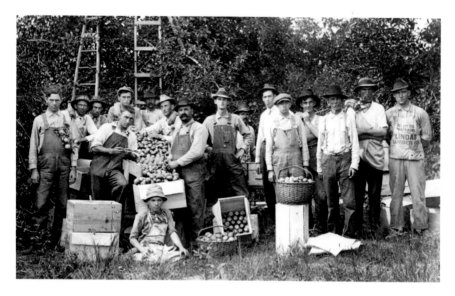

Ozark apple orchard pickers. *Siloam Springs Museum.*

According to *The Drunken Botanist*, people drank cider for a variety of reasons up until the twentieth century. Americans might drink a pint or more per day, but many had few alternatives if not near a clean water source:

> *Water really wasn't a trustworthy beverage in these times, as it could carry typhoid fever, cholera, dysentery, E. coli and many other parasites and diseases not well understood at the time. All people knew was that they started in water. Cider offered a better alternative, as it was mildly alcoholic enough to discourage bacteria, safe and enjoyable to drink, even in the morning.*

So everyone, including children, could drink it. Even among adults, hard cider has always been low in alcohol content, usually about 4 to 6 percent, because apples themselves are low in sugar (much less than grapes, for example, according to Leo Orpin). In a vat of cider, once the yeast has eaten all of the sugar available and finished converting that into alcohol and carbon dioxide, it dies, and fermentation stops there.

If feeling inspired to grow your own cider orchard, head to the local fruit free nursery for advice on apples that survive in your climate. The great thing about growing cider apple trees is that they naturally resist pests and bugs, because their fruit is not as sweet, according to Stewart.

"Any damage they receive will be negligible in light of the fact that they'll soon be crushed to make cider. The apples themselves are classified in the cider world by descriptors like sweet (low tannin, low acidity), sharp (low tannin, higher acidity), bittersweet (higher tannin, lower acidity) and bittersharp (higher tannin, higher acidity)." An example of a sweet cider apple is Golden Delicious, while Granny Smith fits into the sharp cider apple camp.

If you just want to taste great Ozark-made cider and not bother with growing your own apple trees (completely understandable), there is one cidery, Black Apple Crossing, that has popped up in the Northwest Arkansas town of Springdale in the last few years. Ironically, Springdale used to be one of the major apple-producing towns for the nation, much like Lincoln. Coincidence? I think not!

"We at Black Apple Crossing pioneered the first cidery in the state of Arkansas," reveals owner Leo Orpin. After Ozark folk watched apples fail in the 1900s, they had to come up with a new economic driver for their orchards, and farmers chose poultry. "So now it's coming back around for us at Black Apple, as our cidery is located in the building that used to be George's Chicken's first office and hatchery. Next door [to our Springdale cidery] is Tyson Foods's first office."

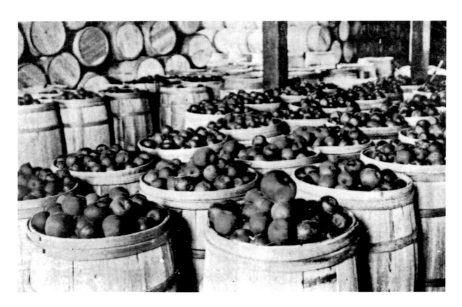

Postcard of apples barreled for shipment, Rogers. *Rogers Historical Museum.*

Some apple peels became cider, and some cider became cider vinegar by the barrel. *Rogers Historical Museum.*

According to Orpin:

Vertical integration is part of the business plan, as we do plan someday to have our own orchards and apples grown specific to the cidery. The good news is apples can grow well here again. We are looking for heirlooms for disease tolerance. A farmer will tell you that Arkansas has too many seasons. That's why all of the coastal areas have the best hops, grapes and apples. They can do more things local there and in California due to having two main seasons versus four changing ones like the Ozarks.

Start to finish, juice to a cider keg, we're looking at a two- to three-month process. Most of that time is used to clarify it. What's cool about cider is it gets a natural clarity just by aging.

This type of real cider is not to be confused with many commercial ciders made similar to beer or malt beverages, using only some apples. Traditional cider *only* uses fermented apples in the mash. In less than a year, this cidery has already seen two of its ciders win awards in an international cider competition, both of which were part of its Ozark series featuring true ciders reminiscent of Arkansas' early apple days.

While cider making may seem daunting, making up homemade apple cider vinegar should not. In addition to being useful in cooking, cider vinegar helps with sprained ankles, according to Ozark folklore, by applying hot vinegar directly on the spot of soreness.

Apple Cider Vinegar

To make your own, simply save the parings from apples and put them all in a big jar with some water and sweetening (honey or sorghum will do). When this turns sour (to vinegar), it is ready to use.

Another use for apples and their cider can be taken back to apple butter–making time in the Ozarks. Many a southern woman recalls the process: making cider from Arkansas Winesap apples, using the evening before to peel about five bushels or so of apples, according to *Ma's Cookin'*. Apple butter making required a lot of helpers, so early the next morning, friends and neighbors would gather, pouring about five gallons of cider, as well as the apples from the night before and ten pounds of sugar, into a huge vat or cauldron over an open furnace fueled by wood. Stirring constantly, people would take turns playing in the woods and hillside until the butter reached the proper consistency (an all-day process) in the Ozark autumn season.

Apple Butter, large batch (adapted from *Ma's Cookin'*)

This old-fashioned recipe for apple butter is made the traditional way: in a copper kettle. Halve or quarter it for home use or make the whole batch (32 pints) for the holidays and gifting. Plus, it keeps fine in the pantry for at least a year if properly sealed. Set aside the whole day from start to finish, about 6 to 8 hours, and invest in a good-quality apple peeler/corer/cutter to save time and labor.

20 gallons apple cider
8 gallons quartered apples (peeled and cored)
15 pounds sugar
cinnamon to taste (at least ¼ cup)

Use a large 30- to 40-gallon copper kettle or multiple large pots. Heat cider to boiling and cook down until half the starting volume over medium-high heat. Add half of the apples and cook until soft. Add remaining apples and cook until soft, stirring often. Add sugar and cinnamon, stirring constantly to prevent burning. Cook until apple butter is a good spreading consistency to coat spoon thickly. Unsalted butter can be added to prevent boiling over, if needed. Can while hot or warm, and ensure labels pop when closed. If not, you will need to use a water bath to seal the lids. Makes 32 pints.

An abundance of stack cake recipes offered by local cooks indicates their prominence in Ozark cuisine. Here's one of the best.

Stacked Apple Cake (by Kelsey Jennings)

1 cup butter or shortening
2 cups sugar
2 eggs
2 cups flour
4 teaspoons baking powder
½ teaspoon nutmeg
½ cup milk
1 teaspoon vanilla
1 quart or more applesauce
½ teaspoon each cinnamon and allspice

Cream shortening or butter with sugar. Add eggs and mix well. Sift flour, baking powder and nutmeg together. Add to first mixture, alternating with adding milk. Add vanilla. Knead in more flour (enough to make a stiff dough). Separate dough into 12 equal portions, rolling out each to a round ¼ inch thick. Pat into cake pans and bake at 450 degrees for 8 to 10 minutes. Set layers aside to cool on racks out of cake pans. Mix applesauce, cinnamon and allspice together. Place mixture between layers thick enough to hold them together, stacking all 12 layers. Top last layer with applesauce. Allow to cool before eating.

The following recipe makes use of two primary ingredients that appear in the Ozarks at the same time every autumn. Be sure to not substitute on this recipe, as often ingredients that grow together in the same area naturally complement each other—just proof that provision and flavor are not mutually exclusive!

Wanda Biggs's Apple Spice Cake with Broiled Walnut Frosting

For the Cake
2 cups flour
1 teaspoon baking soda
¾ teaspoon salt
¾ teaspoon cinnamon
¼ teaspoon ground cloves
½ cup shortening
1 cup firmly packed brown sugar
1 egg
1 cup sweetened applesauce
3 tablespoons vinegar (white or apple cider work well)
1 cup seedless raisins

Sift flour, baking soda, salt and spices together. In a separate bowl, cream shortening until soft and smooth, adding brown sugar gradually until light and fluffy. Add egg; beat until very light. Combine applesauce and vinegar in a separate bowl. Add alternately with dry ingredient mixture. Stir in raisins. Turn into well-greased 8-inch square pan. Bake at 350 degrees for 45 minutes.

For the Frosting
2½ tablespoons butter, melted
½ cup firmly packed brown sugar
2 tablespoons cream
½ cup chopped walnuts

Combine all above ingredients together and spread on finished cake (cake can be warm). Broil whole cake 4 inches below broiler until icing is bubbly.

PIE AND SWEETS

To look at why pie, dried fruit, Bible cake, candy pulls, molasses and other homespun sweets are so popular in Northwest Arkansas, one has to look back into its history. In the Ozarks when times were tough and pockets were shallow, "makin' do" was just what people did. No sweet shows this better than the humble pie. Ozark pies were largely composed of an abundant fruit crop. Besides drying, pickling or canning it, fruit could also be baked into a pie. Apples, of course, were a major fruit crop in Northwest Arkansas, as were abundant summertime peaches and nut trees dotting its forests with ripe harvests in fall. Leaving nothing to waste, early settlers made the most of all that grew native. Wild berries, including huckleberry, blackberry, strawberry and blueberry, were all popularly used as pie fillings, as were orchard fruits and nuts. Pie fillings usually only required the fruit, sugar (or another sweetening) and some kind of thickener. Thus, even those with little resources could make pies if they had access to an oven or heat source, enabling them to feed their family for one more day. Suffice it to say this also added a little sweetness to the rough Ozark life.

A pie crust is still handmade (at least the best ones are) using flour, water, butter or fat and sugar, per *Joy of Cooking*:

> *Well-made flaky pastry is a conundrum at times—it must be firm and crisp while simultaneously having a tender, light, and flaky consistency. Pie crust pastry's strength comes from gluten—a complex chain of molecules that develops when flour is moistened and handled during the mixing and*

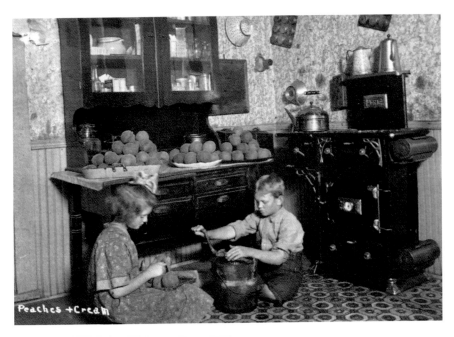

Above: A rare scene of children making peaches and cream by Suttle and Rice. *Siloam Springs Museum.*

Left: Great peach pies start with a crate of Elberta peaches from Siloam Springs. *Siloam Springs Museum.*

rolling out of the dough. Tenderness of dough all depends on the fat, which if properly distributed, prevents too much gluten from developing and thus separates the dough into paper-thin sheets.

This fat, be it butter, lard or shortening, is what creates the flaky effect as a fork pierces the layers of a great pie crust. No one recipe for crust works for all types of pie filling, nor is there a recipe that can completely convey the fabled "touch" of making great crusts or the look and feel dough should have at its perfection. Just like the historic pie makers of the Ozarks, this touch and familiarity comes with practice.

Short Pastry Crust (by Betty Colburn)
makes 32 crusts

Try your hand at this large-batch recipe for pie crust and never be deterred from making a pie in limited time again. Just make them all at once, freeze separately and mail me a thank-you card!

Place 5 pounds flour in a large mixing bowl, cutting in 3 pounds shortening with knives or a pastry cutter. In a separate bowl, mix together 1 teaspoon salt, 3 cups cold water and 1 cup Karo syrup. Add liquid to other mixture and mix until thoroughly blended. Separate dough into 32 round balls and flatten each, placing each crust into a plastic bag with seal. Place all crusts into a larger bag and place in freezer. Thaw out crusts as needed.

Jerry Leding, co-owner of Gooseberry Pies in Bentonville, remarked of the last few decades when women actively joined the workforce, "Pie fell out of fashion for a while because people didn't have time anymore to cook and bake. There was no one to teach them; thus, pie making skipped a generation or two." Now, it seems to be back in fashion to make pies at home, but for those who still don't care to bake, Jerry and his daughter Sarah stay busy making pies for Ozark families at their little pie shop. He

tips that he's always used shortening (for fifty-two years now) as the fat in his crust and that for latticework pies, it's best to cut an odd number of strips for a nice presentation.

The making of pies has indeed become an art form and beloved staple in many restaurants of the Ozarks, not just pie shops. The Klassen family, owners of the Wooden Spoon Restaurant in Gentry, has chosen for their slogan, "Come for dessert, stay for a meal." Dessert is an understatement at this High South establishment. This is the kind of local fixture that makes people drive from miles around to dine and possibly wait a spell, just for lunch. The pie and desserts are so good that a line usually fills the lobby and spills onto the porch and handmade rocking chairs outside. They're only open Monday through Friday for lunch and Friday night dinner and are always packed—that's how much Arkansans love their pie! This down-home cooking restaurant serves up fresh food of the High South cuisine palette, but their pies are their claim to fame. Among flavors often on their daily blackboard, one finds apple, cherry, peach, lemon meringue, bumblebee (mixed berry), strawberry, pumpkin and sweet potato.

To back up pie's importance in High South cuisine, one needs only look at Wooden Spoon's 2015 Thanksgiving pie preparation (which this author was privy to witness and photograph). This one restaurant in the Ozarks made over 370 pies in two nights to fill orders, according to Jenna Klassen. That's a lot of pie! The demand for pie is still strong in the South, and everyone in Arkansas is having pie at Thanksgiving.

Jane Klassen, co-owner, still takes pride in making their pies by hand— and as is commonly known, homemade makes all the difference in a pie, especially the crust. "When most people are making this many pies," Jane stated, "they have a machine that crimps it [the crust], but we do it all by hand still. We haven't upgraded yet!" Judging by an order of over 370 pies for one holiday alone (made in just a couple nights, mind you), it seems the upgrade may not be necessary. When asked for her secret tips on good pie making, Jane recommends, "Make sure you have a good flaky crust recipe. That's half the pie! Use plenty of sugar. An old grandma once told me that especially in an apple pie, don't scrimp on the sugar. I used to put ¾ cup [of sugar] in a pie, and she said, 'No, do a cup,' and it made all the difference!"

Included below is Jane's generously shared apple pie recipe, with lots of love and sugar.

The Wooden Spoon's Apple Pie

Prepare pie crust. If you don't have your own recipe, try the short crust pastry recipe mentioned earlier in this chapter for 2 crusts. Do not prebake the crust.

For Apple Filling

Mix well 4 cups Granny Smith apples, sliced, peeled and cored, with 1 cup sugar, 2 tablespoons flour and 1 to 2 teaspoons cinnamon. Let sit 10 minutes.

Place bottom crust in pan, gently pushing into corners and up the sides of the pie pan without tearing. Fill crust with apple mixture. Pie can be made with or without a top crust. If you have prepared a top crust, place that over filling and pinch bottom and top crusts together along sides. Brush a glaze on top crust with 1 egg yolk. Bake in oven at 350 degrees for 40 minutes.

Jane Austen once said, "Good apple pies are a considerable part of our domestic happiness." Many people love to bake at home now as well as in Arkansas' past. Nanny Jackson, a housewife who left behind an 1890–91 diary encompassed in the book *Vinegar Pie and Chicken Bread*, lists pie making as one of her favorite activities. Nanny often blessed others with gifts of food despite the fact that the Jacksons were a poor family in Arkansas. When fruit was unavailable or if cupboards were nearly bare, desperation or make-do pies (like vinegar pie) came through in a pinch. These poor man's pies were made with minimal on-hand pantry ingredients. Popular nationwide during the 1800s, the Dust Bowl days and the Great Depression, they have remained a part of Arkansas' heritage. Even with next to nothing in the larder, it's highly likely one will have enough to make at least one of these make-do pies.

All's Good Pie (by Leena Ollie Brewer)

1 cup sugar
½ cup butter, melted or softened
2 eggs, beaten
1 cup raisins
1 cup walnuts, chopped
2 tablespoons white vinegar
1 prepared pie crust

Mix sugar and butter. Mix in eggs, raisins and walnuts well, then vinegar. Pour into prepared pie crust. Bake at 350 or low heat until done (about 20 minutes or until filling is set).

Buttermilk Pie

1 unbaked pie crust
½ cup butter
4 tablespoons flour
½ teaspoon salt
2 cups sugar
2 eggs, slightly beaten
1 cup buttermilk (or milk with a teaspoon vinegar or lemon juice)
1 teaspoon vanilla

Preheat oven to 350 degrees. Place pie crust in pie pan and set aside. Melt butter in large bowl. Add flour, salt and sugar. Mix well. Add beaten eggs, then buttermilk and vanilla. Do not overbeat; just stir until combined. Pour into unbaked pie crust. Bake 45 to 60 minutes, until center is only a little jiggly. Cool and refrigerate to serve.

In the Ozarks, Easter is a time for egg hunts, picnics and delicious dessert. *Rogers Historical Museum.*

Besides pies, Ozark folk practiced other methods to make sweets and preserve them. Orchard fruits like peaches and apples in the Ozarks were often preserved through drying in open air before modern-day refrigeration and food dehydrators. Peaches or apples could be cut into slices and laid to dry on home-built scaffolds. These vented boards would keep fruit off the ground and away from animals. According to *Garden Sass*, one Ozark woman said the best scaffold she ever had was an old screen door because the air could reach the fruit from both sides. Varying responses exist on the length of time it takes to properly dry fruit, but nearly all agree that drying fruit should be brought in at night. Night air, according to folklore in the Ozarks, made fruit black—well, that or the morning dew. A sheet placed underneath the fruit made it easier to move the fruit in and out because it could be rolled up and brought inside daily. People also often dried large amounts of fruit on rooftops in Arkansas. One walk through the Ozark countryside in the 1800s would reveal barn roofs and cabin shingles laden with drying fruit in summer and fall, effectively keeping most animals away. Just watch out for the birds!

A rooftop, however, did not keep some brave children away from drying fruit. Longtime Arkansas resident Gail Brewer remembers getting in trouble

for being on top of the barn sneaking apples at the age of four. Grandma Brewer let Miss Gail "know what for" with a whoopin' using a tree switch on many occasions for climbing onto the barn roof to snatch drying fruit. Still, Miss Gail survived to tell her family tales. She still loves apples and thankfully has shared Grandma Brewer's dried apple recipe below. You can dry and eat them switch-free, no whoopins' included, thank goodness!

Dried Apples

Cut your cored apples (as many as you like) into ¼-inch-thick rings across the apple, leaving the skin on. "My Grandma Brewer used Jonathan apples because that was what they grew most during that time [mid-1900s Arkansas]." Set in drying place in single layer. Turn your apples over once per day for as long as it takes them to have shrunk to less than half of their original thickness. Store in an airtight container. Can be eaten as is or baked into a pie. Use the Wooden Spoon's apple pie recipe above, doubling apples and adding ½ cup more sugar and ½ cup water to rehydrate dried apples.

In addition to drying on scaffolds or rooftops, one particularly ingenious way to dry fruit was by hanging it in hole-pierced bags on a line or tree. Few insects could get inside, plus the fruit dried on all sides and could easily be moved inside and outside as needed. Hanging also kept the fruit less accessible to critters.

Even if fruit was the showpiece of Ozark desserts, other sweet treats found their way into social gatherings and community events like these:

The church supper was a big fundraising event, as churches had meager budgets, particularly to pay their pastor (one dinner in 1885 raised eighteen dollars to pay their minister—for the year, according to *Garden Sass*). Food was donated for the supper by the women of the church, who used it as an opportunity to show off their culinary prowess.

Pie auctions were similar opportunities for local ladies to see their pies admired and bid upon to raise money for a new school or church. These old-fashioned auctions still take place in tiny Ozark communities like Falling

Springs, where once a year thousands of dollars are raised to help local people in need. Suffice it to say, it's not unusual to see a pie go for up to $300!

"**Poundings**" were a type of housewarming for a new minister arriving to a community. The name formerly derives from the pound of a staple item each person brought to contribute to the pastor's larder.

Church and social events were often accompanied by an offering of Bible cake, per *Garden Sass*. The Old King James version matches the scripture quoted best.

Bible Cake

1 cup (Judges 5:25) butter—"She brought forth butter in a lordly dish."
2 cups (Jeremiah 6:20) sugar—"To what purpose cometh there to me incense from Sheba, and the sweet cane from a far country."
2 teaspoons (1 Samuel 14:25) honey—"And all they of the land came to a wood; and there was honey upon the ground."
6 (Jeremiah 17:11) eggs—"As the partridge sitteth on eggs, and hatcheth them not…"
4½ cups (1 Kings 4:22) flour—"And Solomon's provision for one day was thirty measures of fine flour."
2 heaping teaspoons (Amos 4:5) baking powder—"And offer a sacrifice of thanksgiving with leaven."
To taste (II Chronicles 9:9) spices—"And she gave the king a hundred and twenty talents of gold, and spices of great abundance."
1 cup (1 Samuel 30:12) raisins—"And they gave him a piece of a cake with figs, and two clusters of raisins."
1 cup (Nahum 3:12) figs—"All thy strongholds shall be like fig trees with the first-ripe figs."

Cream butter, sugar and honey. Beat eggs until frothy, sometimes stated as, "Follow Solomon's prescription for making a good boy—Proverbs 23:14—'Thou shalt beat him with the rod.'" Add milk, then cream the mixture and add in eggs. (Since milk amounts are left out, milk amount should be enough to moisten the mixture (½ cup) until it runs off a spoon.) Sift dry ingredients together, add to wet ingredients. Chop raisins and figs and flour them before adding. Stir until blended. Bake at 350 degrees in a large cake pan until set, about 45 minutes.

Learning to bake started at a young age. *Gail Brewer.*

In addition to the home, church and community gatherings where Ozark folk shared sweets, schools and children were making their own dessert traditions with candy stews to pull honey or sorghum molasses into confection. To make molasses candy, one needs first to make sorghum molasses.

The culinary machine behind sorghum is a story in and of itself, according to *Garden Sass*. Sorghum making was a neighborhood gathering and an all-day activity, if not done over multiple days. People seemed to look forward to sorghum-making time of the year, usually in September, as the fields were laid but the big crop harvest was not yet underway. Even though it was still hot outside and flies and bees came by the thousands during the process, this was a minor inconvenience. Most people were also out of sorghum, also known as molasses, by this time of year and glad to have some more sweetener. Sorghum, due to its long-lasting flavor, was called "long sweetening," while honey was "short sweetening." Most farmers had a sorghum patch growing on their land to provide their family with sweetener in addition to honey. If you grew enough cane, you might have surplus to sell after paying the man with the sorghum press with some of the bounty. Any extra stalks (similar to sugar cane) not used for making sorghum molasses could be stored as a winter treat for the pigs.

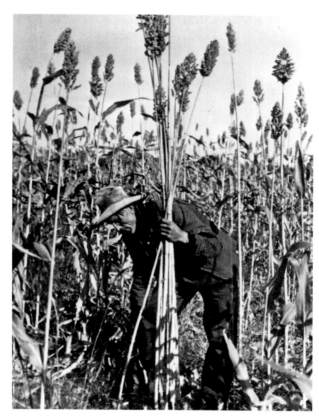

Left: Sorghum starts with growing sugar cane and harvesting it. *Rogers Historical Museum.*

Below: A farmer must feed the mill constantly to press enough cane juice for reducing to sorghum molasses. *Rogers Historical Museum.*

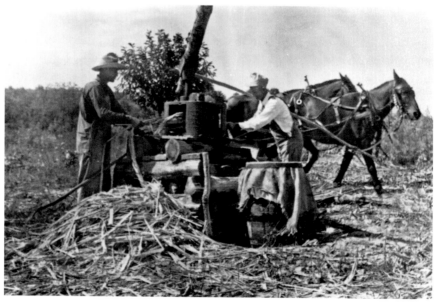

Making sorghum is really quite simple, just time consuming, reveals Cane Hill resident Archie Reed. Stalks are stripped of their outer leaves by homemade paddles (the sturdier the wood, the better) that are swung through fields like windmills to strip efficiently. The stripped cane is taken to a nearby sorghum mill, where it is crushed by a cane press operated by mules or horses. Today, tractors may be used for the driving power of the mill. Then the green juice that results from the pressing is cooked down until it is the right consistency for sorghum molasses. Historically, this was done in a rectangular partitioned copper pan (about ten to twelve feet long). The juice had to be strained of its "scum" constantly and pushed along the pan to different sections with a rake, a wooden block on a long handle. Heat for cooking the sorghum down was provided by a wood-burning furnace near the mill. Sorghum mills, like many other mills of the time, were run on tolls or shares; no money was exchanged. The man who brought the cane was in charge of putting it in the mill and providing the firewood in the furnace. He also took all the pressed juice from the mill to the copper pan to cook it down.

Most farmers insist on tasting the cane juice before boiling down, as well as along the way, to ensure a good flavor and correct consistency. "You gotta get it real good and thick before it turns to sorghum," declares Mike Reed of Cane Hill. One of the best ways to test sorghum molasses is to take a cup of it and set it in a cold-water bath. After it has cooled, stick a spoon inside the syrup. If the molasses and its glass container can be lifted by the spoon, then it's done and at the right consistency to be dubbed sorghum molasses.

If sorghum is boiled down a little too long and hardens easily, it can be turned into candy by grabbing three friends and pulling it like taffy. Children at candy stews and pulls could make a candy with sorghum akin to brittle, per Nancy McDougal. After boiling the syrup down a good bit, baking soda was added to make it foam up. Then that mixture was pulled until it got white and bright. Pulling candy both ways was difficult and could be hard on the hands, but the finished product was a nice and rare sweet for early Ozark settlers and children to enjoy. It was also a chance to meet up with neighbors and friends, as multiple people were needed in the process (from pressing, to skimming, to stirring and pulling candy).

Today, sorghum is not made using neighborhood mills, which have gone by the wayside much like whiskey stills. Sorghum, too, is carefully regulated and hard to find in Arkansas in its original, unprocessed form. Still, one can find the processed version all over the state and enjoy it over pancakes, waffles and biscuits in place of syrup.

The Ozark sweet scene can be summed up in pies of all sorts, dried fruits, sorghum, pulled candy and delicious cakes to bring to the church social or local barn-raising. Yes, all these things do still happen in the Ozarks, and once in a while a breakfast table is set with all the standard savory fare, plus dessert like biscuits and chocolate gravy.

Biscuits (by Randy Brewer)

High-rising heavenly biscuits so good they need a halo!

4 cups self-rising flour
¼ cup canola oil
3 cups milk

Mix ingredients well and roll out onto floured board. Cut with biscuit cutter (or drinking glass) with minimal working of the dough (which toughens it). Place rounds carefully on baking sheet and bake at 450 degrees for 15 to 20 minutes. Great with fried chicken, sausage or chocolate gravy.

Chocolate Gravy

Corrupting heavenly biscuits in the Ozarks since the early 1900s!

4 cups milk
¾ cup sugar
¼ cup cocoa
½ cup flour
dash of salt
1 teaspoon vanilla
1 tablespoon butter

Heat milk over low heat and mix dry ingredients together. Add them to the milk and cook until thick. Add vanilla and butter. Pour over hot baked biscuits or pancakes. Ain't life sweet? Sure is…in the Ozarks!

THE FUTURE OF OZARK CUISINE

Food is our common ground, a universal experience.
—James Beard

The 1916 *Nyal Cookbook* published this description of the importance of food (independent of who prepares it): "There are so many attractive things a young housekeeper wishes to possess and her income is so inelastic that she is apt to scrimp on the food supply." So true, especially in these days of our fast-food nation! "This is the poorest kind of economy," meaning this is the worst way to save a buck. "The drains on the energy and vital forces of young people are many and these are to be met almost wholly by food. To be able to put forth his best effort and do a good day's work, be it mental or physical, a man must be well-nourished. The largest intake of food is needed at about the age of twenty-four years." OK, so in a nutshell, the workers of the family—today often both adult members—need decent and good food, particularly in their early twenties, to do their best work physically and mentally at their jobs. As if that isn't enough fodder for thought, "The children in the family are building bone, nerves and tissues and their condition *throughout life* will depend upon the provision of proper building materials at this period. A woman can undertake no more important business than this of supplying proper food to her family." While it may be easy to chide the early 1900s–50s as a time of domestic servitude, it can still be understood that underneath it all the truth of knowing food well enough to provide for a family was once valued. Let us value it once more so that

AQUATIC PICNIC PARTY, NEAR SILOAM SPRINGS, ARK.

An aquatic picnic party near Siloam Springs reveals Ozark folk have always known how to find a good meal! *Rogers Historical Museum.*

children and families can grow healthy, starting young so that the value of food is taught and lives on to the next generation. How else will kids learn if we don't model and eat the types of foods that are best?

Further, suggestions of going to the market oneself versus sending a house boy are made. Buying economically and wisely must be done in person, not over the phone as it could have been done in 1916, according to the *Nyal Cookbook.* "Meeting with the butcher in person and other food-sellers can prove profitable for the cook." Expanding that to today's time equates to buying locally, from local butchers and specialty purveyors, neighbors with gardens and at farmers' markets. Know your food; don't just pick it up at a grocery to-go center or order it online, no matter how convenient it may sound. You must pick out your own food yourself to obtain the best quality for yourself and your family. Enjoy the process of knowing where your food comes from and share it with your kids.

Back in 2013, the region's current food system was assessed and sought to be understood, both in its challenges and possibilities for building a sustainable regional food system in the Ozarks to increase production, consumption and access to local food, through use of the Northwest Arkansas Regional Food Assessment. According to its website, www.nwafood.org, this assessment

uncovered findings that the Ozarks indeed produced high-quality local food with superb flavors, but unfortunately, the local demand of consumers exceeded the supply because of unused farmland, lack of crop diversity and a production system that preferred the safety of national supply chains over local distribution to restaurants and groceries. Even if food producers become a dominant part of the Ozark scene, they fall to the background without infrastructure or start-up money to finance their dreams. Essentially, the future of Ozark cuisine being accessible to all, including restaurants and the regular consumer, lies in four recommendations being followed through:

1. The Ozark regional identity must be fostered and understood in regards to the food (enter this book!).
2. Regional supply must be coordinated and grown (enter the green space and agricultural incentives/education Rick Parker is advocating with Open Space).
3. Public resources must be used to improve local food access for the Ozarks through diverse outlets (think the community gardens and "pop-up" farmers' markets we're seeing in many cities, including Springdale's Mill St. Market).
4. Help develop local food area's technical assistance and resources (think a community helping local farmers and small businesses manage their day-to-day business at onset until they get a handle on it; volunteers are needed!).

R Family Farms owner Roger Remington knows if we don't move toward the direction of protecting open spaces, we will see farmers go by the wayside. The free-range chicken, beef and eggs he raises with his wonderful family are motivated by his passion for farming, not the money he's making from their sale.

According to conservationist Rick Parker, "You've got to be so dedicated [as a farmer] in addition to dealing with the current tax structure, which is prohibitive in itself." To make it sustainable for farming again, "we're gonna need tax breaks to be able to do small farms. You can start getting crops like fruit trees going in about two years. They [early Ozark folk] were really good at planting crops in between waiting for orchard crops. Given the success of farmers' markets and if you could link up with little retailers, then the conversation needs to happen that suggests buying Arkansas-grown over California-grown or out-of-state. Couple this with the knowledge that Arkansas at onset couldn't provide all the needs; it just needs a foot in the

door of retail spaces. Let us work into this. It's gonna take a lot of things like tax breaks for farmers and retailers. It's a whole different thought process, and corporate types get entrenched. It's hard to get an idea, even a great idea, to the right people. If you do get it to the right people, then instantly, bing…it starts happening."

As homemaker Wanda Biggs confirms, "I think we need a mindset change." Parker encourages, "There are a lot of young people, if the option were available to them, that would do farming. The problem is that if you want to do it, you have to learn; it's not an overnight decision. It's seriously a learning curve. You've gotta really know how to do it, which is why agricultural programs and small farming would tie in with universities, extension services, things like that. Right now we have people who could do this (and teach this) at present, but ten to fifteen years from now, maybe not."

We can even invite visitors to our farms. According to food author Kat Robinson, agri-tourism is one way we can take the future of our food back to the farm. Just look at Dogwood Hills, a homestead guest farm in Harriet, where people can come to help milk the cows and play with Boer goats and free-range chickens. With a dream to provide full farm visits for tour groups culminating in a farm dinner, owners Ruthie and Thomas Pepler aren't far from being a big part of the movement to incorporate farms into our tourism model as an effort toward sustainability and experiential education.

Wanda Biggs says, "There was some reason people did the things they did back then and it actually was best, like soaking beans, and maybe they just heard of what to do from cooking stories passed down. You're looking at a health food book too, that you're doing…because it doesn't have the processed items listed. We need to go back to the basics and roots of our foods." If we are talking free range and organic, there's no better way to achieve this than by growing your own food and learning to hunt your own meat. Our traditionally "poor folk" cuisine is now the envy and trend of the masses.

"Community gardens are a big move toward the right direction mainly because they make good food more accessible," says Hunter Davis. "If you're taking 5 percent [of the land] and giving that back to the community, it's then expanding the community and expanding that variety of choices. That's how we make it affordable to eat healthy. Grace Place's community garden in Lincoln gives produce baskets to the homeless. At Briar Rose Bakery, we donate a lot of great food to benefit the needy and homeless through programs like Life Source. It's an opportunity for them to change food choices."

Men dining alfresco at an Ozark fishing and hunting camp, 1914. *Rogers Historical Museum.*

For now, we need only look at what Tri-Cycle Farms of Fayetteville is doing in its urban space of two acres, growing a small farm of fruit, vegetables, herbs and flowers to help feed its neighbors in an impoverished part of town. Tri-Cycle has many food-insecure families living within one mile of the farm, and it uses one-third of its produce to hold a "Sunday Supper" at a nearby church weekly, completely open to the community. According to Emily Anne Jackson, the organization also sells at the local farmers' market and gives back to its volunteers who work the space through food gifts. It's working to transform an urban space, showing those who can afford it that farming can be brought within city limits, as well as helping provide food to transform society by reconnecting with neighbors who desperately need food. Working the earth is a great way to equalize the playing field, as status and gender roles are nullified under the mutual bond of stewarding our common soil. As founder Don Bennett reveals:

We can throw a pebble in the pond and create a ripple. Change the neighborhood, change the city, change the country. We can feed thousands of people, because we can teach them the culture of food that we have been missing for several generations. We can get back into our soil, and we can

connect with each other on a different level. We can connect with people on all walks of life.

Tri-Cycle even hosts field trips for schoolchildren to be educated on where food comes from and how they can grow it or help out locally through community and school garden programs.

"About 75 percent of our student body is involved in agriculture classes and FFA [Future Farmers of America]," states Lincoln student Hunter Davis. "Even the Arkansas Garden Corps is a local body that teaches young leaders to build school gardens and teach nutrition to their peers. In the last ten years, the Farm to School movement has really had an influence on Ozark schools, and local farmers are gaining another market from these kids that will grow up to be hopefully responsible eaters and consumers."

Similarly, the Siloam Springs Farm to Table dinner helped bring together farmers and their supporters under one white tent on a local farm. Here people ate together, listened to local live music and enjoyed a farm tour and an old-fashioned dessert auction. Here is an event that can be duplicated in about any town in the Ozarks or elsewhere, where buyers and growers meet together in purpose and appreciation on the land that provides a reason behind it all.

Karen Wagaman, vice president of Downtown Development with Rogers-Lowell Area Chamber of Commerce, recognizes that

these farm-to-table markets provide inviting venues where food producers, artists and craftsmen sell their products and interact directly with the consumers of their goods. The markets also provide a gathering place where patrons may interact with each other and experience a sense of community while directly supporting their local economy. The value of the farmers' market goes well beyond the sum of goods exchanged. It provides a sense of place and purpose and an opportunity for people to experience food and entertainment in community in a vibrant, colorful and local marketplace enhancing the urban experience.

Former Siloam Springs Main Street director Meredith Bergstrom agrees:

Downtowns and other town or neighborhood centers have proven to be a symbiotic place in which markets and restaurants like this can thrive— the walkable environment, density and destination-feel can be a local entrepreneur's best bet in finding a home for locally produced products. This

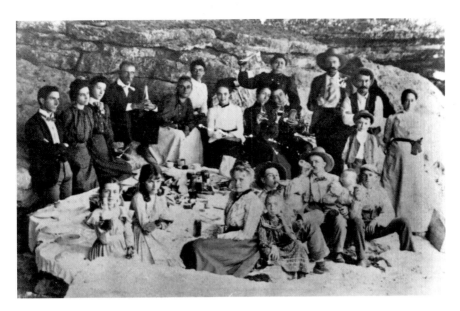

A Cave Springs 1901 cave picnic is proof that Northwest Arkansas has always been home to unique dining venues. *Rogers Historical Museum.*

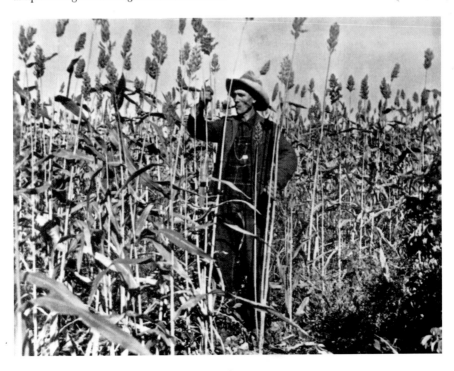

You can still find sorghum (from cane like this) and local honey if you look at farmers' markets in Northwest Arkansas. *Rogers Historical Museum.*

relationship also helps to further define what makes a town or downtown special and unique; visitors and customers who see local products at a market or on a menu know they can't find that particular item anywhere else....

It's been particularly exciting to me to see farmers' markets continue to expand and thrive in Northwest Arkansas. The definition of local food culture has also expanded, I think, to include the cultures and food traditions of diverse backgrounds. Many Hmong immigrant farmers and farmers of Hmong descent participate in selling fresh vegetables at farmers' markets in Northwest Arkansas. They often grow local varieties of herbs and plants (watercress or apples, for example), as well as Asian ones (like bok choy, ginger and bitter melon).

Student Hunter Davis agrees, also listing the expansion of Cajun influences on the cuisine, possibly a result of large groups displaced from Hurricane Katrina to the area a few years back. For increasing diversity to Northwest Arkansas' food, just look at the taqueria-lined streets of historic downtown Springdale. Small shops sell delicious street tacos with cilantro, lime and onion, in all meats from lengua (tongue) to carnitas (pulled pork). From Charley's to Taqueria Guanajuato, it's impossible to ignore wonderful Mexican and Salvadorian food popping up as a result of our changing food and people culture.

As our food culture changes and we become more aware of eating locally, it must be kept in mind that restaurants don't have it easy when we request farm-to-table food without understanding their perspective and focus. Take it from this chef-turned-author's previous experience on the line. We as consumers may want our restaurants to serve local, but maybe we don't want the higher price it requires. We must first understand the risk involved (traditionally) for restaurant owner and farmer. While we might risk not getting a slice of apple pie in spring or a tomato on a burger in winter, the real risk is so much higher for those who grow and cook the meal on our plate. It has been historically risky for restaurants to rely on local farmers when supply can change depending on season and weather, as well as if food just plain doesn't get delivered efficiently. Restaurants need food delivered consistently in the amounts and in timing to keep business flowing smoothly like it would be with a commercial supplier. It makes sense to have a local food coordinator to ensure that eating local is also a good thing mutually for restaurateurs and farmers. What that also means, which consumers need to learn, is seasonality. That means if tomatoes aren't in season, they might not end up on a salad. With that salad,

it'll change and won't always be romaine or iceberg, but more unusual greens that grow at varying times of year. A food coordinator would ensure restaurant deliveries on a consistent schedule, so the farmer and chef would know what to expect, as the romantic notion of buying all produce from a farmers' market isn't really time-efficient or always easy for a busy chef. So if people can change expectations that local food can run out, menu boards can change and even menu items will be prepared differently each time, we are going in the right direction. Restaurants have to care enough to make investments in greater storage for more fresh goods, farmers must feel safe taking risks and consumers must be willing to eat whatever is available, versus anything they want—all growing pains in reaching a sustainable mindset. If a cooperative and a food coordinator can buy and distribute food on a regular schedule, restaurants can begin to trust a local supply chain. The food system of the Ozarks needs stabilization, as well as patience and understanding, as consumers encourage and allow for the bumpy ride it'll take to get there. The end result will be well worth it. All good things come to those who wait.

Places like the Farmer's Table Café in Fayetteville have already been pioneering this mind reset for a few years. They back up their farm-to-table claim with gusto. According to their restaurant motto and servers, they source 90 percent locally, with delicious items like an Ozark Eggs Benedict called Benny on a Biscuit, containing local free-range eggs, Canadian bacon or local greens on a house-made biscuit. They use all natural products with a commitment to organic and chemical-free. Even at The Hive in Bentonville, a gourmet take on southern country cuisine is happening with links to local sourcing, obvious with James Beard–nominated Chef Matt McClure's focus on serving quality ingredients.

Restaurants like Mockingbird Kitchen of Fayetteville are serving up cuisine reminiscent of our southern food culture, particularly with menu salads like Beans and Greens, a collection of soy beans, black-eyed peas and brown beans with seasonal greens and cornbread croutons, tossed in a pepper vinaigrette. That's High South food deconstructed. The Fish and Grits is a catfish blackened in a cast-iron skillet, served over creamy grits with a southern tomato gravy and sautéed shrimp. Chefs can take Ozark ingredients and combine them in new ways. Miles James, of James at the Mill fame, has opened up MJ Pizzeria in Springdale, serving up pies with house-cured Italian sausage, Arkansas bacon, ham and local mushrooms, as well as locally grown hydroponic greens from Ozark All-Seasons.

The earthy roots of High South cuisine are found in the simplicity of a summer day fishing barefoot. *Rogers Historical Museum.*

Chef Bill Lyle of Eleven Restaurant at Crystal Bridges shares, "To keep High South cuisine good, you need to integrate fusions with it. We have so much nuts, livestock, fruits and vegetables available. But I like to do a fusion with our ingredients to really elevate the cuisine. We do a lot of smoking. Lots of grains, beans and braising. We really like to help our local farmers."

According to Jillian McGehee of *About You* magazine, Northwest Arkansas Community College's latest culinary school should be turning heads as the college toasts its twenty-fifth year. Brightwater: A Center for the Study of Food specializes in the culinary inquiry process so that students learn not only cooking skills but also how food is grown from farm to market, including their integral role in a responsible supply chain. Glenn Mack, the executive director, is proud to return to his Arkansas roots to run the new eighty-thousand-square-foot facility focusing on food reuse, as well as helping students to work in food as an art, wellness and business model so they can shape their careers in Northwest Arkansas and beyond. In addition to this innovative approach to food, beverage and bakeshop, the program also focuses on culinary nutrition and food measures to control waste and insecurity. Butchery, charcuterie and fermentation are a few of the many classes offered in a state-of-the-art setting, elevating the potential

for our High South cuisine by ensuring many future chefs and culinary instruction for the area's residents.

It's clear that many of the recommendations to improve our food availability and focus in Northwest Arkansas are possible. They are not all difficult but require absolute intentionality. This new mindset and model can be applied to other farm-rich areas of our country, not just Arkansas. People can learn to volunteer to help their neighbors with balancing spreadsheets of a new business, working in a community garden, educating kids (especially their own) and fighting to maintain their farmland by understanding that their area has a unique food identity that will be lost otherwise. If we want fresh food in the Ozarks that is sustainable, we have to pay the price. At first that might be literally a higher financial amount until eating "local" becomes more accessible and mainstream. Little steps like purchasing a couple items from the farmers' market will encourage people to grow more, as well as supporting local businesses that are already taking the bulk of the risk. Find restaurants that feature farm goods and ask for those in places that haven't jumped on board yet. We must be a part of the solution if we want one, finding a way to give back, either monetarily through goods we buy or support or even with our time. There's a kid out there who still thinks green beans come from a can and chicken is that meat wrapped in cellophane. Reconnecting with our roots isn't hard: host a neighborhood picnic, cook again or learn about your region's cuisine. Spread the word and the tablecloth. It's guaranteed to be a delicious adventure!

BIBLIOGRAPHY

Ashmore, Harry S. *Arkansas: A History.* New York: W.W. Norton & Company, Inc., 1978.

Blevins, Brooks. *Arkansas/Arkansaw: How Bear Hunters, Hillbillies, & Good Ol' Boys Defined a State.* Fayetteville: University of Arkansas Press, 2009.

Bolsterli, Margaret Jones, ed. *Vinegar Pie and Chicken Bread: A Woman's Diary of Life in the Rural South, 1890–1891.* Fayetteville: University of Arkansas Press, 1982.

Braly Letters, Cane Hill Museum.

The Cane Hill Presbyterian Church, U.S.A., pub. *Recipes and Reminiscences of Cane Hill.* Cane Hill, AR: Cane Hill Presbyterian Church, U.S.A., 1984.

The Encyclopedia of Arkansas. St. Clair Shores, MI: Somerset Publishers, Inc., 1998.

Gold Medal Cookbook. Minneapolis, MN: Washburn-Crosby Co., 1904.

Herald Leader. "Simmons Celebrates Its Golden Anniversary." March 31, 1999, 6.

Hill, Janet McKenzie. *Nyal Cookbook.* Detroit, MI: Nyal Company, 1916.

Jackson, Emily Anne. "Growing Community at Tri Cycle Farms." *Edible Ozarkansas* (Winter 2015–16): 34–36.

Kieser, Kenneth L. "Shadows on the White River." *Arkansas Wild* (Winter 2015): 26.

McDonough, Nancy. *Garden Sass: A Catalog of Arkansas Folkways.* New York: Coward, McCann & Geoghegan, 1975.

McGehee, Jillian. "Savory Education." *About You* (August 2016): 32–33.

Mitchell, Ruth. *Arkansas Heritage.* Little Rock, AR: Rose Publishing Company, 1986.

Northwest Arkansas Council and the Northwest Arkansas Regional Food Council. "Northwest Arkansas Regional Food Assessment 2013." www. nwafood.org.

Rafferty, Milton D. *The Ozarks: Land and Life.* Fayetteville: University of Arkansas Press, 2001.

Robinson, Kat. "On the Farm in Style." *Arkansas Food & Farm* (Fall Harvest 2016): 16.

Rogers Morning News. "Don Tyson Never Forgets His Roots." January 8, 2011, 12.

Rombauer, Irma S., Marion Rombauer Becker and Ethan Becker. *Joy of Cooking.* New York: Scribner, 1997.

Schoolcraft, Henry R. *Schoolcraft in the Ozarks: Reprint of Journal of a Tour into the Interior of Missouri and Arkansas in 1818 and 1819.* Van Buren, AR: Press-Argus Printers, 1955.

Sis & Jake. *Ma's Cookin'.* Osage Beach, MO: Ozark Maid Candies, 1969.

Stewart, Amy. *The Drunken Botanist: The Plants that Create the World's Great Drinks.* Chapel Hill, NC: Algonquin Books of Chapel Hill, 2013.

Whayne, Jeannie M., ed. *Shadows Over Sunnyside: An Arkansas Plantation in Transition.* Fayetteville: University of Arkansas Press, 1993.

Whisler, Frances Lambert. *Indian Cookin'.* Chattanooga, TN, n.d.

Wilson, Charles Morrow. *Stars Is God's Lanterns: An Offering of Ozark Tellin' Stories.* Norman: University of Oklahoma Press, 1969.

INDEX

ABOUT THE AUTHOR

Erin Rowe was raised in charming Siloam Springs and calls the hills of Northwest Arkansas home. She attended Maui Culinary Academy but mostly learned by trial and error, cooking her way through the infamous *Joy of Cooking*. Its stained pages have followed her moves around the world many times. She first wrote about food penning restaurant reviews for *Maui No Ka 'Oi* magazine. When not catering house parties and cooking for her adventurous husband, Alex, she's eating basil pesto, collecting passport stamps or reading through a British classic over a good cup of coffee. Also, roller skating. But not bicycling, ever. Should you wish to talk food, exchange a recipe or share a comment, please e-mail erin2maui@hotmail.com.